15 YEARS

In a photographer's life

NADINE BLACKLOCK

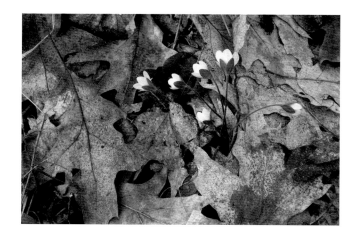

For my mother, Carol Kolar

15 YEARS
In a photographer's life

5 4 3 2

Library of Congress Catalog Card Number 97-093330
ISBN 0-9634991-7-3

Book design: Nadine Blacklock
Cover design and image processing:
David Garon/Digital Ink; Nadine Blacklock
Separations: Northern Images, Duluth, MN
Printed in the Republic of Korea:
Dong-A Publishing & Printing Co. Ltd.

Published by:
Blacklock Nature Photography

Distributed by:
Adventure Publications
Cambridge MN 55008
800-678-7006

15 YEARS

In a photographer's life

NADINE BLACKLOCK

BLACKLOCK
NATURE
PHOTOGRAPHY

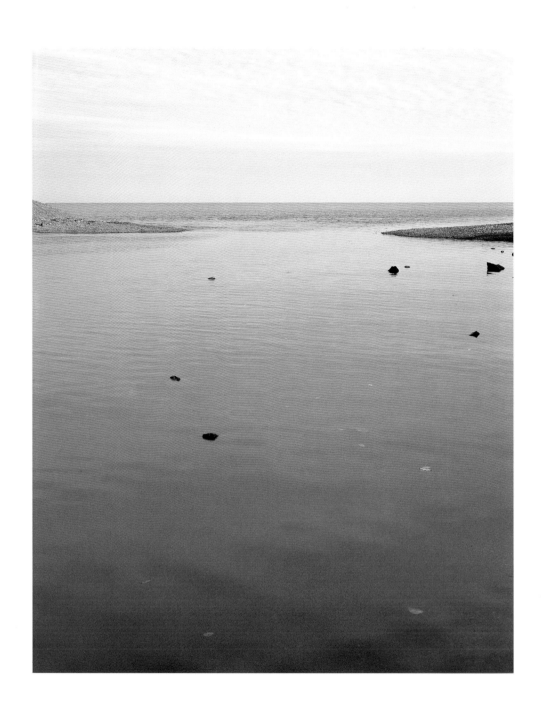

CONTENTS

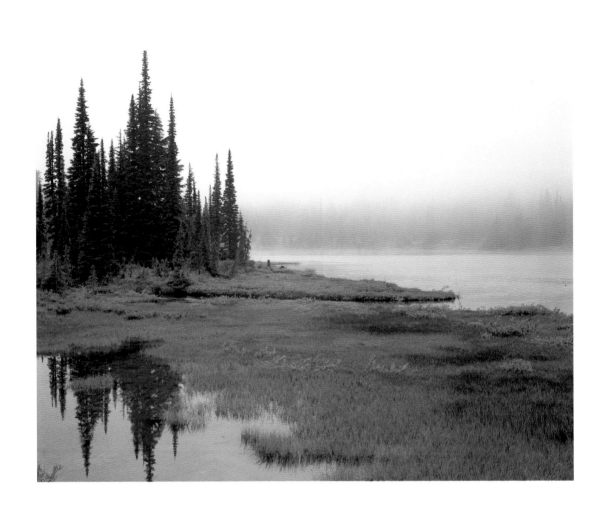

Beginning

There is copious discussion about the definition of art and artists. This debate involves judgment from all quarters on how to best be an artist, how to evolve as an artist, and which stamps of approval have the greatest prestige in the art world and in the general world. Those of us compelled to create, whatever the medium, are aware of this mine field of opinions. We want to follow tradition, add to a collective body of work, and yet be true to ourselves. Tall orders take time to fill.

In this book I share with you some of my work, my experiences, myself, as I've traveled with and without cameras during the last fifteen years.

I often hear that what I do does not lend itself to the blessings of the art world. My work is sometimes viewed as literal: I am published "commercially" in calendars, posters, and books accessible to everyone, yet this means that I can be with a camera more hours than the person who works a nine-to-five job and pursues her art in the evenings and weekends.

I do not seek to shock, exploit, disturb, or emulate someone else. I do not think black-and-white photography is necessarily more worthy of the label "fine art" than color photography, or that certain subjects or genres are more serious than others, or that one type of darkroom process is loftier than another. Nor do I think that a person must be conflicted, depressed, manic, or promiscuous to be able to create significant artwork. On the other hand, I am thrilled that improvements in lenses, film, paper, chemistry, and computer software have enabled us photographers to more closely reproduce what we see in our mind's eye.

Regardless of where my photography is seen, whether it is seen by many or only me, it is *mine*. It is an important part of my life, but only a part of my life. With me personally, what you see is what you get. The same applies to these images; they don't need hundreds of words of analysis or a guessing at their purpose. Trust your instincts—you can appreciate a photograph (or a piece of music, a sculpture, a poem) whether it fits your personal taste or not. Critics, committees, gallery owners, and funders play a role in bringing art to you, but the final decision about its importance does not rest with any one individual or group. It is the one-to-one communication between creator and viewer that matters.

Look at these images. Discover the nuances. Listen to your response.

1982

What is it like to make a long-planned leap from a salaried position to being self-employed? What is it like to finally join my husband Craig and his parents Fran and Les in the family business? It is a transition that offers great opportunity and great responsibility. I've had a camera in hand since I was twelve. Now I will return to large format work, seeking compositions in the natural world. I am eager to photograph the large landscape, to share a place, to bring the outdoors in.

I am conscious when composing that these photographs will be considered for the family's *Minnesota Seasons* and *High West* calendars. My vision thus has some predetermined parameters, but this doesn't diminish my enthusiasm. On my first trip I am atop cliffs in beloved Minnesota canoe country framing images of blue sky and blue water, carefully fitting the pieces together.

My next trip is to southwestern Minnesota in August, car camping with our dog, Nuka. We rise in the dark to be out on the prairie in the dusky pre-dawn light. As I hike up a knoll, I savor the still air and relish searching for the composition that will convey space, quiet, sky. Midweek Nuka and I explore state park trails. She waits patiently when cone flowers catch my eye. The overcast sky and dark woods subdue the flowers' lemon-yellow color. I work unhurried. My new time schedule is one guided by light, not a clock.

In many ways, my biggest initiation to this new way of life is a two-month autumn solo trip to the West, primarily Washington State and Oregon. While planning and packing, my confidence level is high during the day, but low in the evening. I don't doubt my map reading, navigating, or camping skills, or even my photography skills. But can I find the images I want, will I find enough images, will they really be good enough, how will I like being in a tent during the long, cool nights when it is dark by 6:00 p.m. and not light again until 7:00 a.m.?

Well, I just have to start, like the proverb, my journey of a thousand miles with one step— into the car and out onto the road. I cross the Dakotas and travel through Wyoming to the Wind River Range, near Square Top and Flat Top mountains. The last thirty miles take two hours to drive. At the road terminus I'm met by a landscape so breathtakingly silent and beautiful that for minutes I simply stand and stare. During my five-day stay, low clouds swirl a misty blanket around me, elk bugle, coyotes sing me to sleep, a grunting bull moose wakes me. Foggy, damp mornings give way to afternoons full of towering cumulus clouds that race by at the speed of time-lapse film. I concentrate on the mid-to-large landscapes. The small things that intrigue me are, at this time, second priority.

I stop overnight at Twin Falls, Idaho, anticipating how good a hot shower and

regular bed will feel. What I don't anticipate is my shakiness sitting in a restaurant and how lonely I suddenly feel. I realize I haven't had a real conversation with anyone for days.

"Chasing Mountains" is what I decide to call this trip. In Mt. Rainier National Park I again find that seeing the stars at night doesn't guarantee a clear morning. For five days I drive and hike in the cold rain, finding images but never seeing the mountain. I am more and more nervous about not having enough photographs. It troubles me that effort expended does not equal output.

Later a break in the weather lets me work a few days with Mt. Hood and Mt. Adams. Next is the Oregon coast, where I don't work much because (and I no longer restrict myself this way) the purpose of the trip is to photograph in the mountains. I have never seen the Pacific Ocean. My first sight of the marvelous, milky breakers pumping ashore leaves me weak-kneed. Their cadence is that of a strong heartbeat, I think, or maybe I'm only hearing my own heart. I walk the beach without camera as long as I dare, feeling guilty for indulging in this pleasure.

At the end of the next storm system I return to Mt. Rainier. It's late enough in the season so that camping is free (in other words, all the water is turned off), and it's cold enough so that every night I frost up the inside of the car, where I now sleep because it's a bit

warmer than the tent. These inconveniences don't matter, though, because I'm feeling more confident about the trip. I have seen and photographed Mt. Rainier. Stellar jays keep me company when I eat, and I sometimes thank them with a bread crust.

One last peak on my list is Mt. Jefferson in the Oregon Cascades. Getting there is another adventure of winding my way over miles and miles of Forest Service roads, seeing no one, imagining I have this almost-wilderness world of giant trees and looming mountains to myself. Self-contained in my small Toyota station wagon, I feel independent, privileged, and joyful. At night, simple soup, sandwich, and tea, prepared by me, is superior to anything I could be served in a place with linen and silver.

The next morning brings a classic rosy dawn, complete with pink mountain and mirror-clear lake. I don't get it on film. But I see it to this day, and also remember how good the coffee tasted a little later, how sweet the air smelled.

Missing a photograph doesn't mean losing the memory.

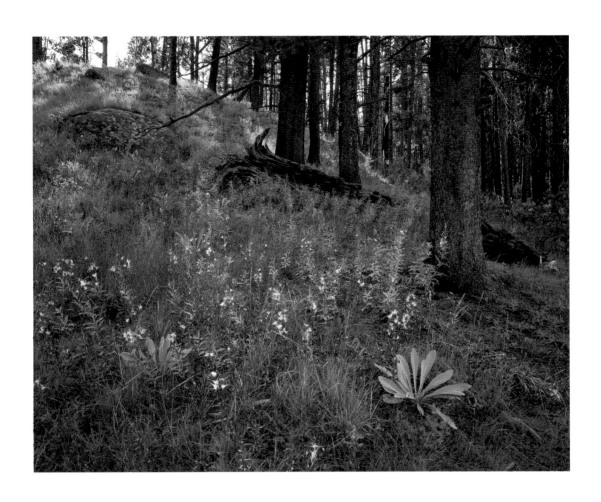

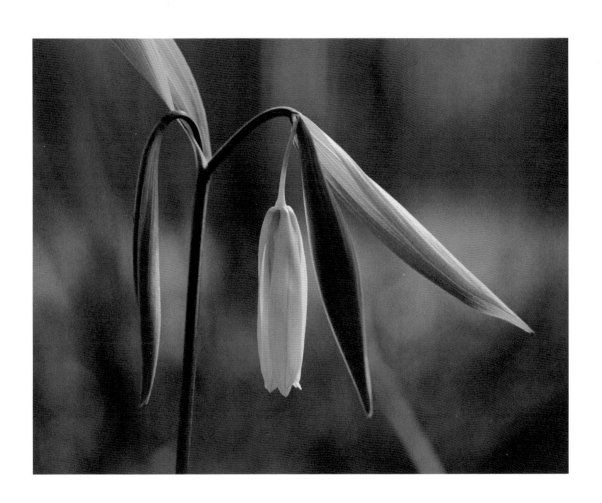

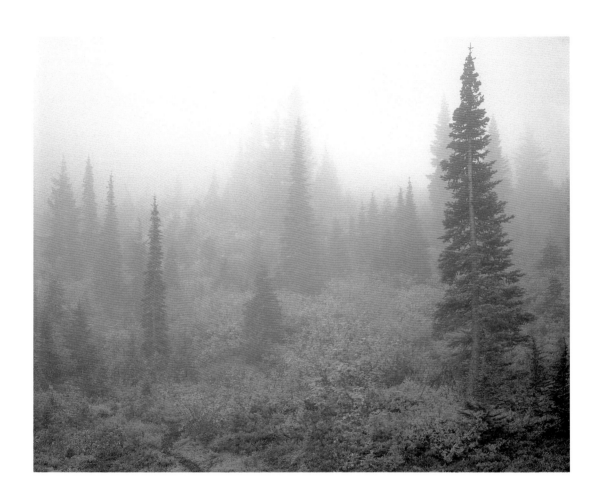

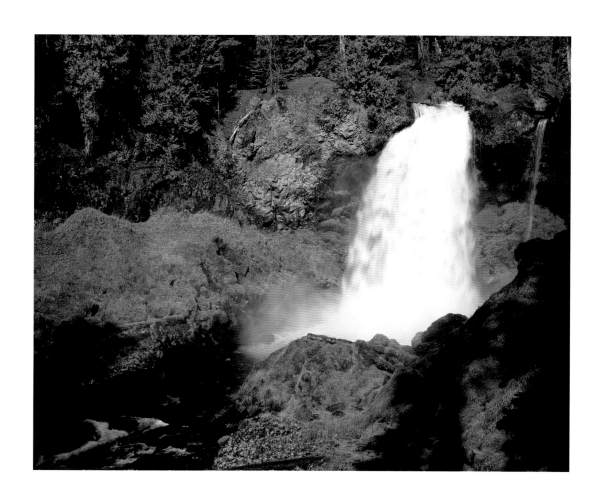

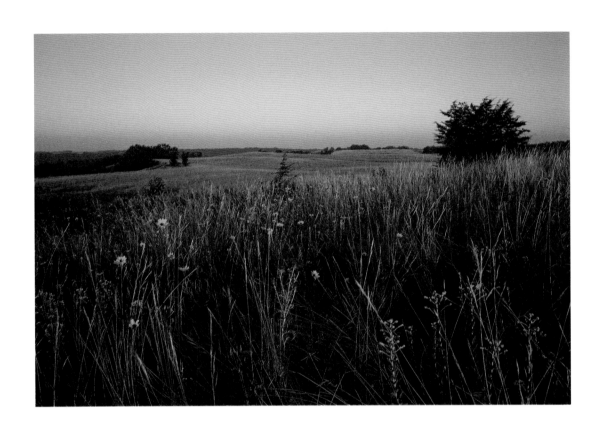

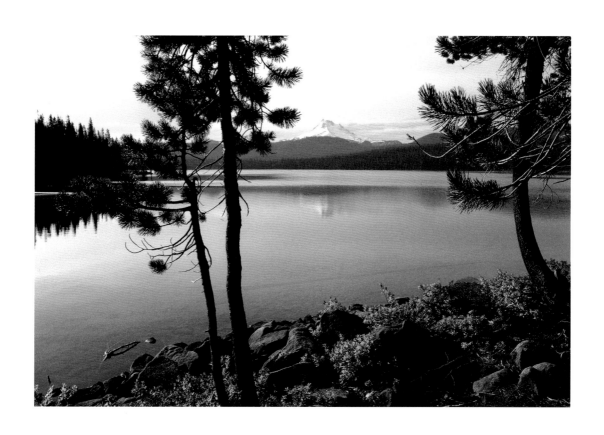

1983

By plane and bus in March I make my way from Minnesota to Lone Pine, California, to meet Craig. We spend five days working in Death Valley, hampered by poor light and rain. I find myself frustrated by the low number of images I am making. Waiting to release the shutter early one morning, I let my mind wander as my eyes trace the edges of the dunes. I think I would like to follow those lines off to the horizon, but I know I won't. As the sun reaches into my composition I release the shutter and return my attention to the work at hand.

We make a few phone calls and decide the place to be is Organ Pipe National Monument, Arizona. The poppies are blooming in record numbers this spring. Once we arrive the question becomes, "Where to start?" The punchy colors, the cactus, the hills, the sky—the possibilities momentarily paralyze me.

I find a group of sunflowers near a hillside covered with cactus and plan the composition before setting up the camera. To give the flowers prominence, I use a low perspective and have their blazing color fill the lower half of the image. A wide angle lens puts them in context by incorporating the background hills and the sky.

Other stops in Joshua Tree National Monument, Point Lobos, Carmel, and Monterey are fruitful, but Yosemite National Park is where I am most awestruck. The tourist in me tingles seeing the classic view of the valley. The photographer in me wants another perspective. I hike up to Inspiration Point, trudging through snow, but I don't photograph because the light is not right. During these early trips I am quite conscious of the cost of film and processing, and debate with myself frequently about how spectacular something must be, about how strongly I must believe in the composition, before photographing it. There is a lot of "should" in this private discourse—I should be making more photographs, I shouldn't waste film, I should be looking harder, I am looking hard and I should be finding something. The pressure we put on ourselves is often the strongest kind.

To distract myself from these thoughts, and avoid any question of taking the camera along or not, I take a long walk at dusk, wandering the narrow paved lanes around the campground. I see some wet spots: bear tracks, distinct and fresh. Looking up, I hope to see the creature who is obviously just moments ahead of me, but all is dark and quiet. I turn back toward camp.

Looking and planning for photographs includes analyzing the light, choosing the perspective, and sometimes even doing a dry run of setting up the camera. This pre-

visualization translates to being practiced and prepared—like warming up, tuning up. I make notes on maps and in a notebook. Then the hand of fate determines if the desired conditions appear the next day, or the next, or the next, if at all.

As the year progresses, I find a higher comfort level about my work. It is probably due to gaining the fluidity that comes with repetition, and decreasing the internal pressure on myself to produce.

I am taking more time to look down, too, photographing what I've always enjoyed seeing—the chance fallen birch bark, bunchberry flowers, mosses, fall leaves, rocks, pools. So what if an image isn't used right now or ever? Does it matter if no one else ever sees it? I will still see it. That has value. If the time spent making the photograph is satisfying, fulfilling, expanding, quiet, then my day has been a rich one, and that richness flows through me to others and other aspects of my life.

In early summer Craig and I are in Door County, Wisconsin, to photograph for an expanded edition of the *Journeys to Door County* book. This book includes images of buildings, sailboats, fishboils, and roads in addition to nature. What is most appealing to me, though, is the translucent evening light that transforms the landscape into dreamscape.

Photography is a subtractive art. We photographers pare away elements. We do not start with the blank canvas of the painter and add to it. We think about what is in front of us and how we will isolate and display the essence that we find important.

Each hour with the camera is an hour of experience stored to enrich the next hour. Time in the field sharpens the senses, gives rise to ideas. Images visualized in the mind are sought in the surroundings. As surroundings are examined additional images appear. Neither the planned image nor the found image is a sure thing; therein lies the addictive lure of random gratification that entices me to look again, to work the visual puzzle until it is complete.

The more open I am to the world around me, the more I find what I seek.

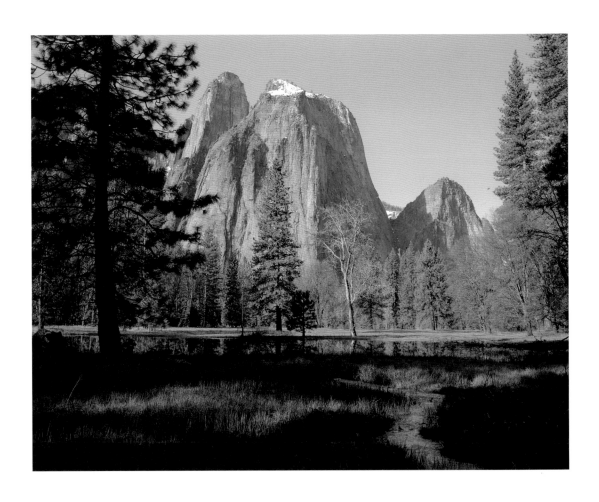

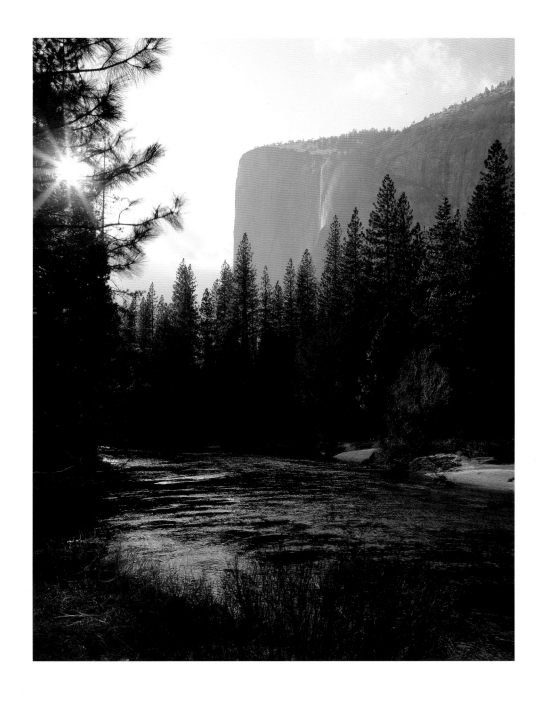

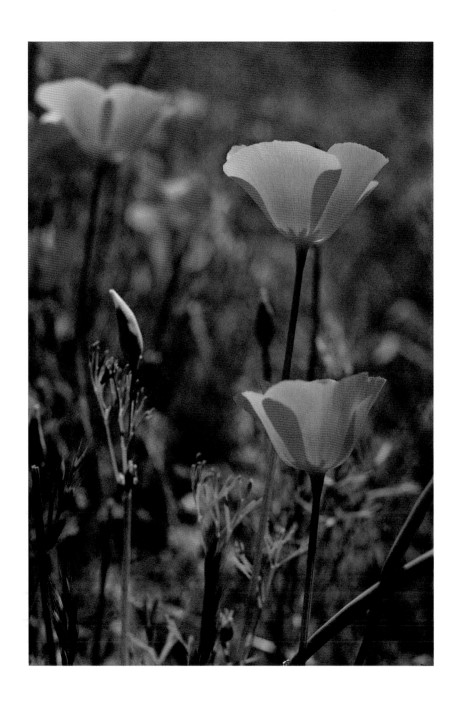

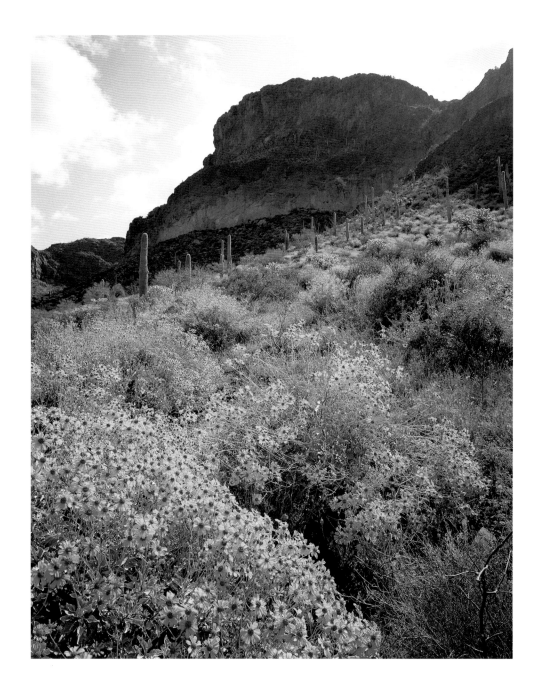

1984

It's been quite a while since I've been in southeastern Minnesota. In January, Craig and I take cameras and maps and explore back roads. I find crisp sunshine, frosted trees, steamy creeks that curve and bend. Other days soft light mutes the hills and valleys.

Come spring I combine a photography trip with a visit with friends. I'm lucky that I have friends who don't disturb my photography time. They leave me alone, knowing working with a view camera often requires an hour or longer for a single composition. That hour can seem like a day to someone impatient to move down the trail or get back for lunch. Yet no matter how many hours I spend with the camera, I would like to spend more.

Reducing my time in the field, though, are the other components of running a business, overseeing production and press runs, teaching workshops, and juggling a myriad of related endeavors.

I look forward to press runs. Since high school graphic arts classes I have loved the smell of ink, a scent pungent and sharp like rain-washed air after a thunderstorm.

In the pressroom we examine early sheets, checking for precise placement and for color balance. More sheets are run, and the color adjusted again. "Add yellow, decrease magenta, increase density," are things we might say. Once approved, the OK'd sheet hangs in front of the pressman. Buttons are pushed, hand signals given. The press shifts to high gear and comes alive. Sheet by sheet, paper is sucked through the monstrous machine in a blur, the rhythm hard and staccato, the decibels high, the pulse palpable.

How wonderful it would be if all these posters, books, and calendars could find their way into consumers' hands by themselves. But of course they don't. We work hard, independently and with publishers and distributors, to present our photography to the public.

This life is one where Craig and I are often apart. I miss time together, yet I know that the nature of our work often requires extended absences. I am used to being alone. One way I adapt is by taking comfort in small pleasures like the heat of coffee lingering in my mouth or the dog's wagging tail, and in the larger pleasure of knowing a certain amount of light on film results in a certain image with certain values.

In September I am doing a press check at 3:00 a.m. I weigh my life, and the pluses outnumber the minuses.

I take a vacation in October to visit a friend in Amsterdam. It is a gift and treasure to lose myself for awhile in a new culture.

The narrow streets, reflections in the canals, the museums, the Anne Frank house; bicycling in heavy traffic, daily food shopping at the corner bakery and local market; the flowers, the concerts, the coffee, the chocolate; the stranger who approaches me on the street and says "You're an American, aren't you?", the cafe owner who tries to overcharge me, the friend (of the friend) who says, "Let me tell you how I saved my dog during the war . . ."; sleeping in a cramped space that serves as seating in the daytime, exploring the city on my own, seeing plumes of smoke in the air while listening to a radio report about the police evicting squatters, taking a quick bicycle ride through the red light district, waiting for my friend in Dam Square on a corner where drugs and money change hands—all of this brings me the same heightened awareness I feel when I am out with the camera. I think again about the paradox of how each of us is both inconsequential and influential. That I am making a photograph on a particular day is of no matter to anyone, yet that photograph may later help convince a legislator that canoe country is worth protecting by law.

On the flight home my seatmate wants to discuss the American presidential election that has just given Ronald Reagan a second term. I am conscious of the need to be polite when I tell him not everyone likes Reagan, and unfortunately many Americans don't even bother to vote; in other words, I don't think Reagan received a mandate. I tell him I cast my absentee ballot for Walter Mondale. We each turn back to our books.

How nice it will be, after the crowded city and crowded plane, to be back on a trail by myself, camera pack on my back, talking to no one, seeking a certain light and form to mold into a composition. I'm ready to be home.

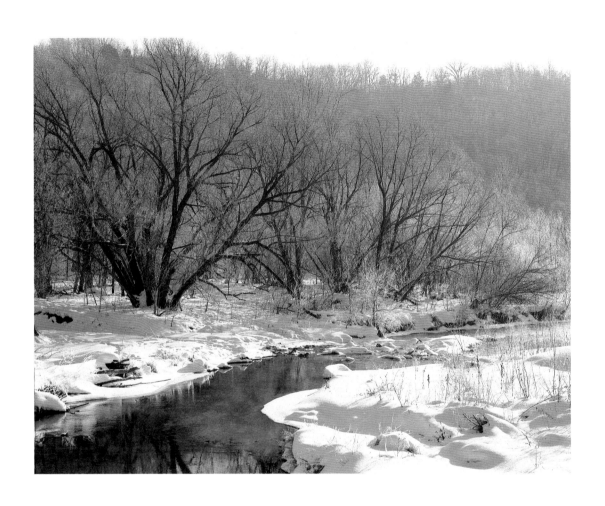

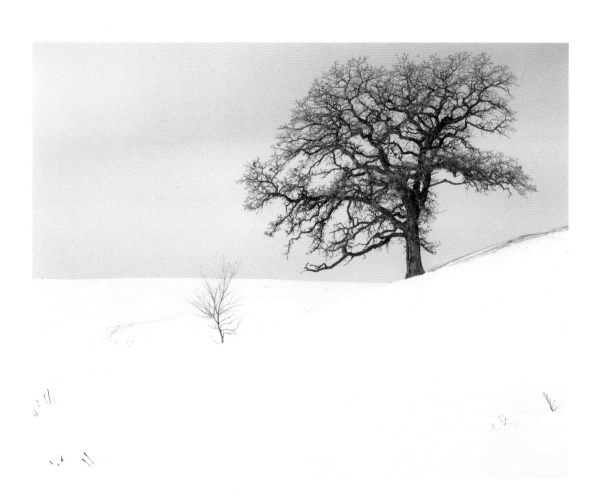

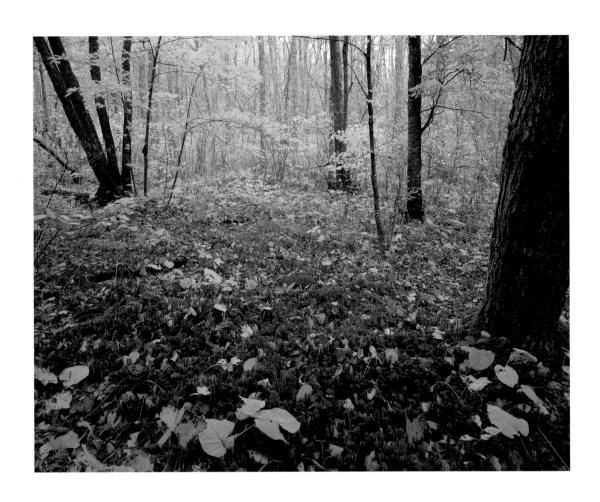

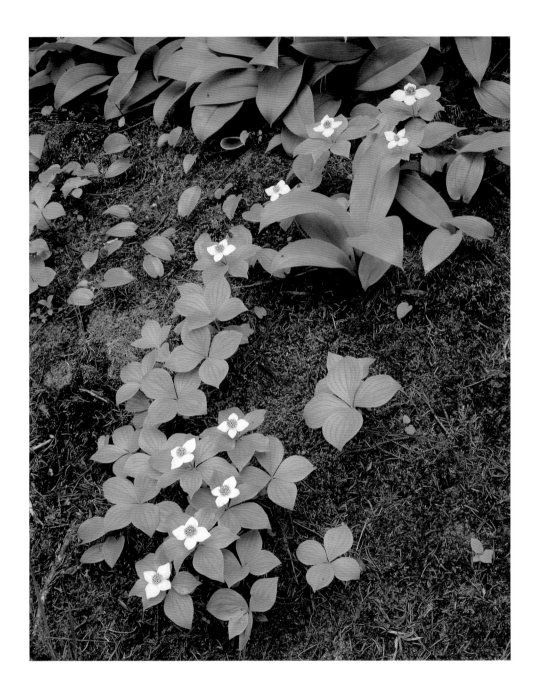

1985

Three years into my linkage of camera and nature I wonder if the first wildflowers will arrive on schedule, and how vivid fall color will be. It is an anchoring, this touching of past and present. Naturalists term this comparison of one year's natural events to those of previous years *phenology*.

This same touching of past and present prevails in any art form. Every artist studies work done by those who came before. Regardless of how many images exist of a flower, a famous landscape, a famous landmark, a nude body, a bowl of fruit, a weathered building, there will always be more made, as long as photographers keep working. We respond to solidness however it is expressed because certain balances are present in all of us.

Yet it is too facile to stay in the traditional perspective all the time. We humans assert our individuality. Artists do it by consciously breaking the rules, by experimenting, by following an inner voice. Here paths diverge. Here I look and find something I am compelled to put on film, regardless whether it appeals to anyone else. I may love it or hate it when I view it on the light table later. I may use it in a book or throw it away without ever filing it. But I have exercised myself in the same way a poet does who writes and later burns a poem, or a musician does who erases notes from a score. The wider audience sees

but an atom of the work behind the moment presented to them. How long does it take to make a photograph? The seconds the shutter is tripped, the years of seeking, the lifetime of creating.

Photographing nature, eliminating the human form and objects, means the viewer can place themselves in the image without invading, or feeling they are invading, the space or privacy of another person. Humans are irresistibly curious about one another. We examine one another closely. There is a larger emotional response to a photograph of a leg or a breast or a face than to a photograph of a rock or a tree.

I like working with a rock or a tree because it waits, patiently, for me. It asks nothing of me. I can touch it, walk around it, spend hours watching the light transform it. As I study and think, my mind focuses, my energy channels.

This summer I am part of a Split Rock Arts Program instructors' exhibit at the University of Minnesota Minneapolis campus. Another photography instructor's images are of suffering people in war-torn and strife-ridden places. His photographs remind us of the depth of pain we are capable of inflicting on one another. The juxtaposition of these images with mine of nature seems to emphasize the tension that exists between good and bad, balance and chaos, survival and death, constancy and instability. All of these things

are part and parcel of life. Each photographer offers a sampling to the viewer.

Creativity ebbs for most artists periodically. Enthusiasm wanes, other interests and outside forces take priority for a time. This changed focus is valuable. Just as one grows tired of champagne if it is drunk as frequently as water, so can one grow tired of repetition in expression. As I search the files of this year, I find a dip in quantity. This is perhaps a plateau year, a catching-my-breath, waiting-for-my-second-wind kind of year.

Ease and familiarity. The upside is confidence, the downside is doubt. This is not as contradictory as it sounds. The confidence comes from accomplishment, acknowledgement, a growing body of work, credibility, acceptance. The doubt comes from the moments the work doesn't seem as satisfying. Times when it is an effort to go out with the camera. Times when it isn't funny that a moment's distraction in the field means a sheet of film is exposed twice, ruining it; when a malfunction in the camera means the film isn't flat on the ground glass, and the image is unusable. Times when the nitty-gritty, putzy office and business tasks are pure drudgery. These things outsiders don't see or think about when they say, "I wish I had your job; it must be like being on vacation all the time."

To keep dissatisfaction at bay, I think of the large context, and keep the bright side more prominent than the dark side. I may grumble, I may have bad days, but my inner voice balances it. I think of the simple basics, the importance of which is too often glossed over: Health, family, friends, food, shelter, a companionable dog, music, books, giving back to others, making a difference somewhere outside myself.

I look at the glass not as being half-full or half-empty, but as always having room enough for more.

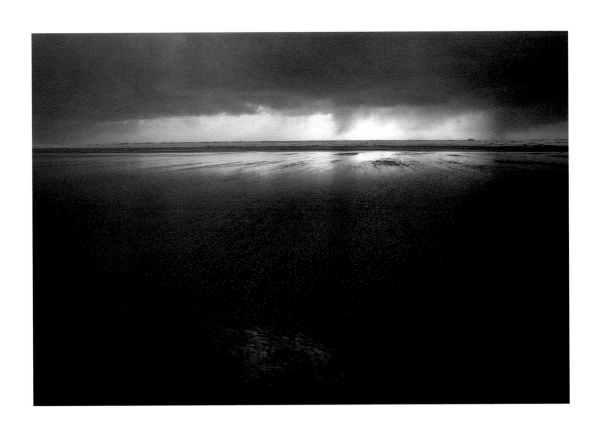

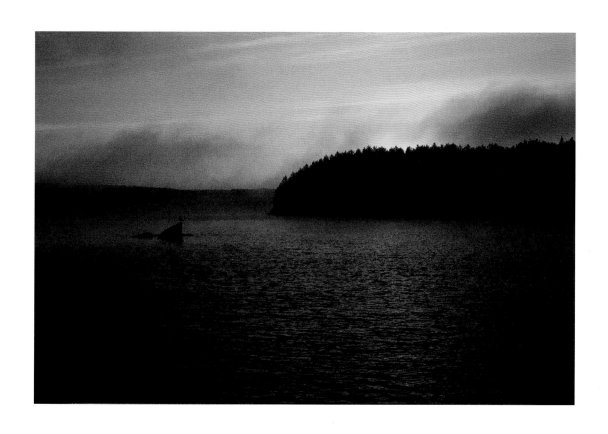

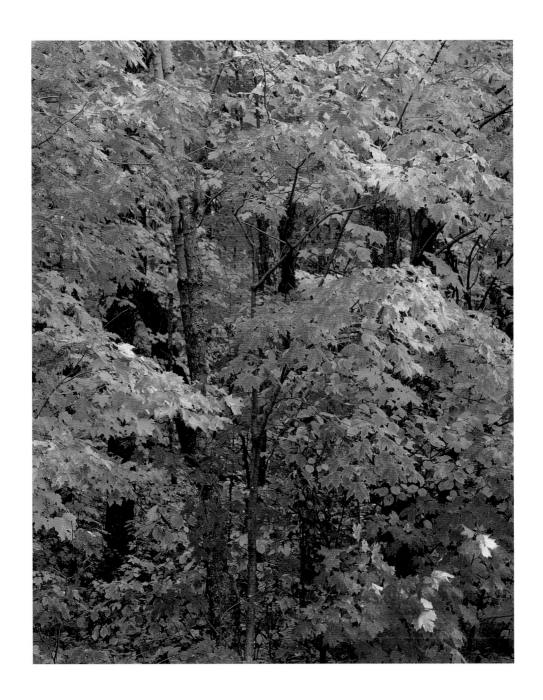

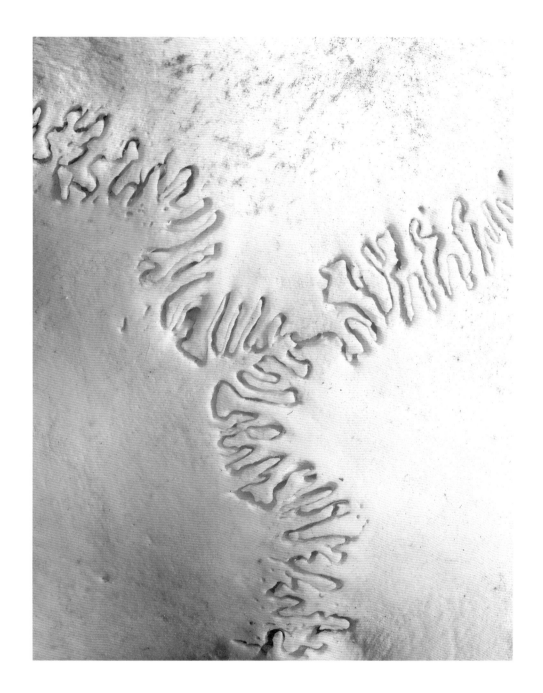

1986

In January I have my first taste of winter camping. The solitude and quiet are nice; a walk by moonlight is nice. Long, cold nights in the sleeping bag are not so nice. Working time is fine, but the dark evening and early morning hours drag. Staying warm diverts energy from my brain to my body, and I feel slower and duller. Nature photography, by its very definition, requires being outdoors in many conditions in all four seasons. It is not always pleasant or comfortable.

Stories about how many miles were hiked or how much it rained illustrate my perseverance in pursuit of my art, but do the conditions in which I work add value to the images?

In May Craig and I sign a contract to do a book on the Boundary Waters Canoe Area Wilderness and Quetico Provincial Park, adjoining wilderness areas on the Minnesota-Canada border. Intense planning and excitement fill our days as we decide how to best portray this place we love. This planning is perhaps what sets photography, and photography about a *place,* apart from other types of art. We have the end in sight when we begin, and carry a checklist for what we want to achieve.

The questions are put to me more than once, "A whole book on the Boundary Waters? How will you get enough variety? Blue lakes, blue sky, green trees—that's really it." And my reply fits any subject: "Variations are infinite." In nature, the seasons, the progression of flowers and fruit, of layers of light, of growth and decay are endless cycles. I, too, look with different eyes each time. I am older by minutes, days, years. More sadness, more happiness, more life has taken root in me. When I walk a trail my feet connect in a way they didn't the last time. When I sleep on the ground, I hear my heartbeat more clearly. These electrical impulses bind me to my raw material. I expand my reach, my awareness. Moss is a resilient cushion for a mouse but not for me; luminescent pink and platinum birch bark is an echo of dawn to my eyes, but not to those of a woodpecker.

This studio is not that of other artists. Nor is my workday always subject to my control. Many hours are spent getting to a location and accomplishing the simple tasks of camping. More often than not, the hunt for images is hours or days long. Curtain Falls, in the interior of canoe country, is a beautiful, well-known cascade. Arriving one afternoon, Craig and I explore near the falls and choose compositions for the following morning, hoping for fog. Our campsite is about forty-five minutes away. Dawn comes early in July. The alarm is set for 4:00 a.m. Up and out we go, barely able to see where we are paddling. We are in luck. Fog steams off the water, the sky is just beginning to blush.

After quickly setting up the camera at the spot chosen yesterday, I have thirty minutes to photograph before the magic is gone. My fingers are numb, and my stomach is growling, but the film has been exposed, and I feel good.

At the end of each trip, after the film is filed, I sit down at the light table and reshuffle the pieces of the growing book. Craig does the same with his images, and then we mix the two sets together looking for the strongest progression and variety. It requires stamina.

To me, a book itself is an art form, composed of complete pieces that relate to the whole. Everything about a book is a choice: a choice of color, style, texture, weight, size, flow. Rarely do photographers get to make all those choices by themselves. Craig and I are increasingly involved in all aspects of our projects.

We like brevity. Too many words, too much complexity can hamper understanding. Another book we are working on this year is an instructional book titled *Photographing Wildflowers*. The title is a bit of a misnomer because the information applies to any subject. The publisher wants us to make it longer, saying it is too slim a volume. We tell him we have written it the way we think it will best help people grasp the principles and procedures. While we are willing to add chapters about other concepts, we are not willing to expand the basic text. This compromise is agreed to, and we are later heartened by many letters from readers thanking us for our succinctness.

The book was partly inspired by oft-repeated questions and comments from our workshop participants: "How do you find your subjects?" "I can't find anything to work with," "It doesn't look the way I wanted it to," and "I'm frustrated."

Photography, unlike some other arts, requires simultaneously engaging technical and aesthetic skills. Unless you are proficient with the tools, and understand your subject matter, you will not achieve clarity in the image. Question your reason for making the photograph, I say. Answer it before you take out your camera. Then value the answer enough to take time and care in exposing the film. Study the composition again when you think you are finished. Do you see something else? What else can you find if you look longer?

Mastery of craft and knowledge of subject frees the vision.

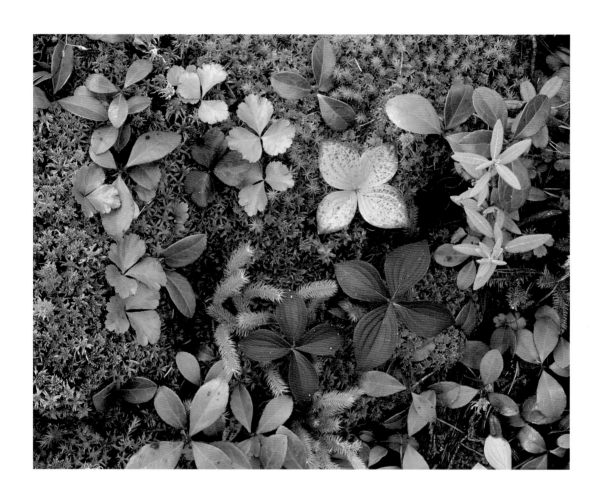

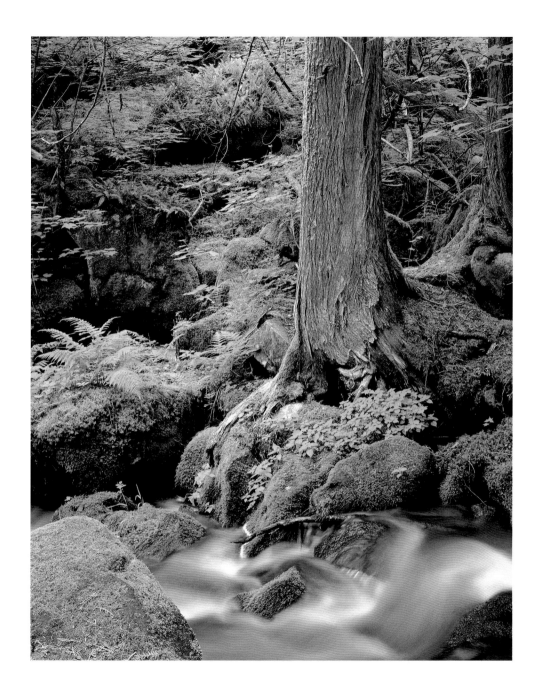

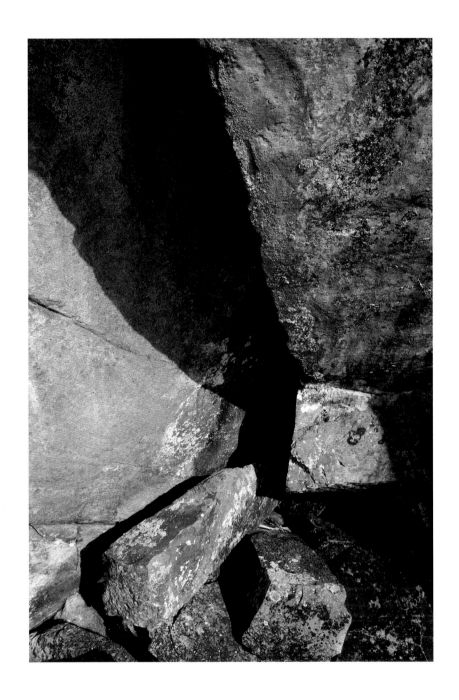

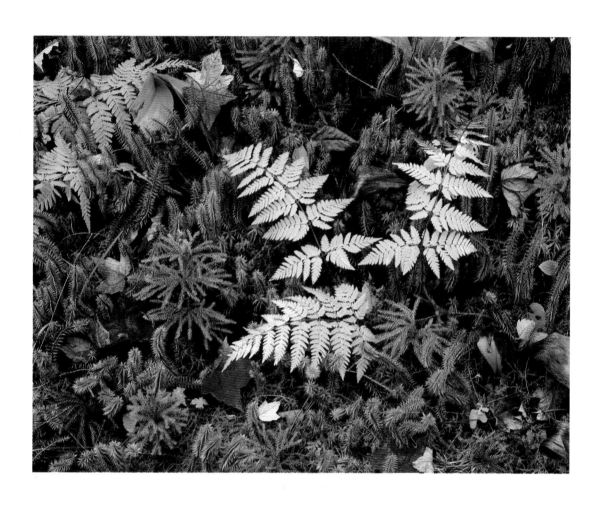

1987

Most of this year's photography is also done in the Boundary Waters and Quetico for the *Border Country* book. We spend so much time in 1986 and 1987 living in canoe country that time at home—with furniture, running water, and a refrigerator—actually feels strange.

The benefit to bare-bones camping is the heightened connection to nature. You have no other-worldly distractions of telephones, television, mail, newspapers. You fit yourself to the day offered.

On sunny, calm days I hum as I set up the view camera, and have conversations with the gray jays that come to watch me. The pace is leisurely.

When the weather turns, my mood turns. Basswood Lake is a big lake where the wind often reigns. When it erupts, it feeds on itself, blowing ever stronger, pulling the water higher, shaking the trees. After six or so days of this I understand how people on the prairie used to go crazy. The noise and push wears me down slowly and steadily. The thin tent fabric snaps and pops all night long.

It is mid-May, but still cold, with frost on the tent every morning. I sleep with my head tucked in my down vest, both for warmth and to muffle the wind.

Curiosity gets the best of me every morning, and I hurry up to a near-by cliff top to view the landscape. Even at 6:00 a.m., though, the light is flat, and the wind gleefully chases away the fog and rumples the water.

Because this is the second year of photographing for the book, the pressure is not as great. The days and weeks of bad weather are not as frustrating as they were last year. It is nice to stay longer at a campsite and enjoy a hot breakfast now and then. And sometimes I just get a feeling about a place.

Rising early improves my chances for entering transient magical kingdoms of setting moons and rising suns, swirling gauze curtains of fog, unearthly colors, rippling light, and silence so complete I think I've gone deaf, except I can hear myself breathing.

I wake one morning to a heavy stillness, and look out at just such a world. I scramble out of the tent. A luminous fog obliterates everything but a tiny island a bit offshore. Placing the island in the lower right corner of a horizontal composition, I have a minimalistic, monochromatic image that is both peaceful and arresting. Every now and then the far shoreline comes faintly into view for an instant. The light is growing stronger, but staying true and white instead of staining pink. Suddenly the top crescent of the sun is just visible. I instantly release the shutter.

The sun waits for no one and now begins a
quick ascent, pulling all the colors up into
the day.

I close my eyes against this too gaudy display,
wanting to hang on to the magic just a little
longer. When the sun touches my shoulder
I open my eyes. The world is again real—blue
water, blue sky, green leaves, brown tree
trunks. I compose a different image, and catch
the last wisps of fog disappearing in front of
my eyes.

Do images of familiar things evoke a greater
response than images of unknown things?
Do we look more deeply or less deeply if the
subject is familiar?

I think the mountaineer looking at images of
Mt. Everest feels more than I do, and I feel
more looking at images from canoe country
than the person who has never been there.
But any of us, if we look beyond the *subject*,
will feel more if we let our minds explore how
the abstractions of form and color fit together
in a symmetrical or asymmetrical way.
Direct and strong, or delicate and soft:
As long as an image is not ambiguous it can
speak to anyone.

When I sense pride and care in the execution
of something, I give it respect as I view, listen,
or read. I think it is important to encourage
the beginnings of expression. I tell workshop

participants that everyone has to begin
somewhere, so don't let comparisons to others
prevent you from doing what gives you joy.
I use the example of one of my own
avocations—music. I play tenor saxophone in
a local quartet. I'll never be a Charlie Parker,
Ben Webster, or Joshua Redmond. But that
instrument lets me speak, and it brings me
vital connection with three other people who
also find music as life-giving as water.

When the quartet practices and performs, we
narrow our world to the present moment.

And so it is when I am with my cameras—
I am fully in the present, my senses are
heightened, my vision is acute.

Because the creative process is so highly
personal, I think it deserves careful, caring
attention whether the audience is one or many.

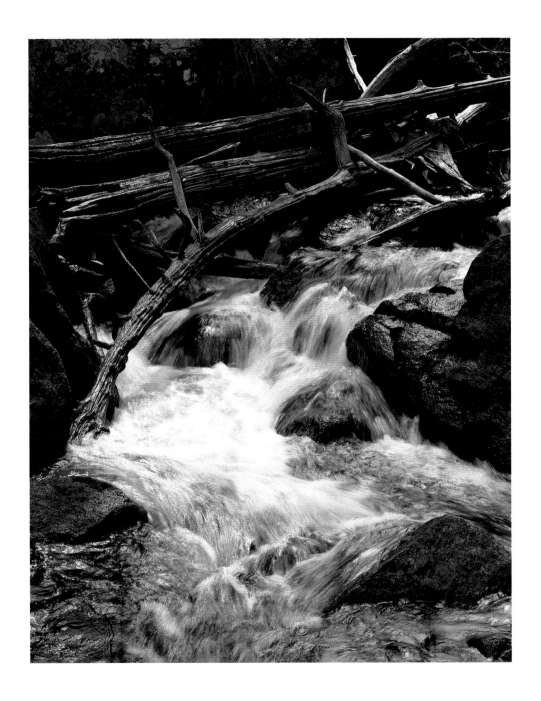

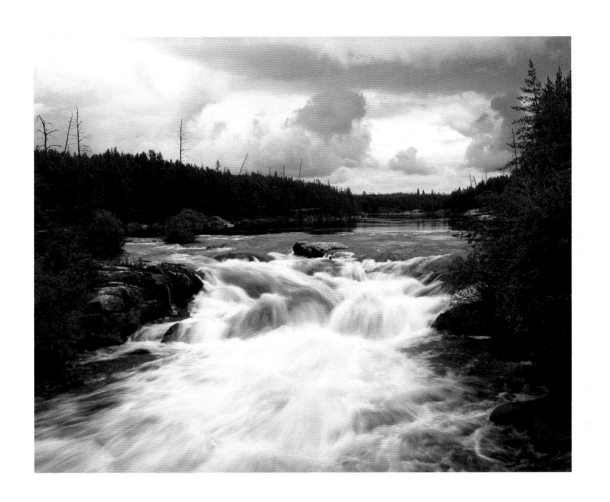

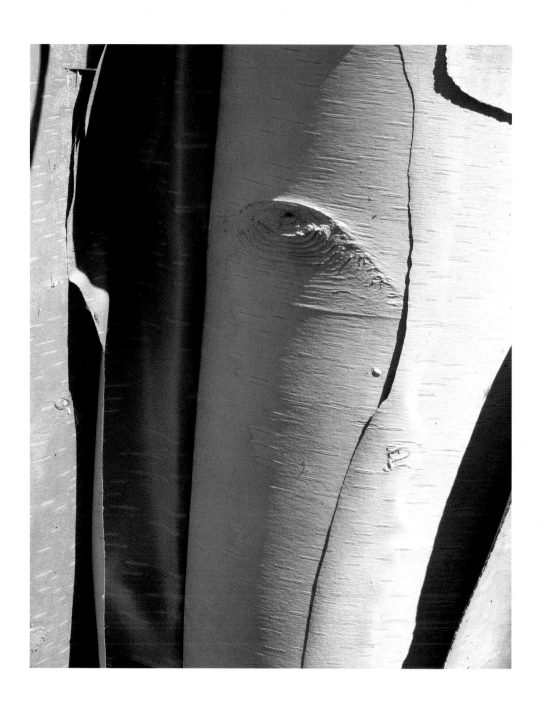

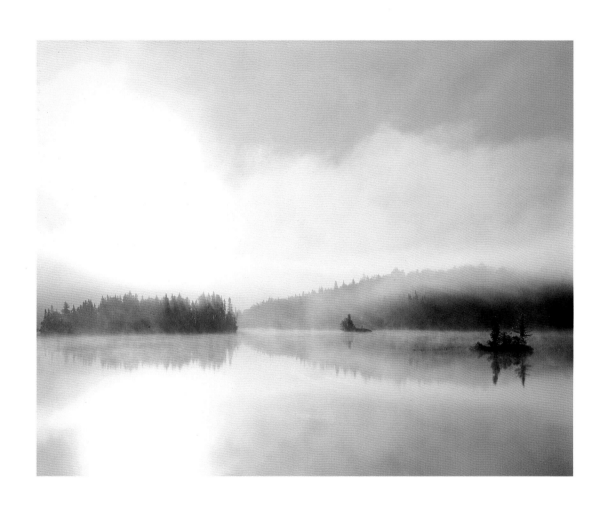

1988

I am again photographing primarily in the canoe country of northern Minnesota. The book this time is a revised version of *The Hidden Forest,* originally published in 1969. Sigurd Olson's text about the delights and struggles in the forest throughout the four seasons is timeless. So are some of the photographs made by Les. The book, first published by Viking Press in New York, enjoyed enormous success, but is now out of print, and we have requested the rights back. Voyageur Press, with whom we have done almost all our projects, is interested in reissuing the title. I'm interested in adding to the photography.

There is a quietness to Sigurd's text. He gently describes, instructs, persuades. I feel that photographs also instruct and persuade. These images of wild places and creatures are advocates—just as much as photographs of war, the homeless, or AIDS patients—in showing people what they may not experience themselves and prodding them to care about the world outside their own lives.

As the title implies, the book seeks to share pieces of nature perhaps not noticed without patience and awareness. I can't count the number of times I've been approached while under the dark cloth and had someone ask, "What are you taking a picture of?" "This group of pink lady's slippers," I once told a fisherman on a portage. "Oh, those funny pink flowers? I didn't even see them," he replied.

I notice greater respect expressed about a particular thing or place when its image is carefully executed and produced on a page, framed in white space, singular, and powerful. The person looking at the pink lady's slippers then says, "What beauty! Isn't it a shame that some people just pick these flowers without knowing what they are doing?" Another may say, "I've never noticed how graceful the curve of the leaf is."

To give pleasure, to educate, to raise awareness—about subject, color, form, grace, balance—that, for me, is one of the great satisfactions of choosing nature as my source of material. Photographs can be appreciated on many levels: the literal subject, the metaphorical interpretation, the lightness or darkness of tone and color. I resist using titles, preferring not to impose anything on the viewer.

Each viewer's response is influenced by their own experiences. An image of a forest in fog is perceived as peaceful by some, as threatening by others. One person may not get past the literal, and wonder why anyone would make a photograph of joints in a deer skull. Another person sees not a deer skull but the lines, textures, tactile possibilities.

And if an image is seen in a book, presented across from another image, the visual experience often deepens. When laying out a book, I give much care to this pairing. What best heightens the impact of both images? Sometimes it's a similarity, sometimes it's a contrast. Sometimes a photograph stands best alone, with a blank page across from it.

Exploring the forest floor and photographing more intimate landscapes is satisfying work right now. There is a "looking inward" and an accompanying sense of quiet. However, positioning myself—both physically and mentally—for these photographs, requires interaction with others and whatever weather exists. On a drive to Ely heavy crosswinds continually push at my lightweight Kevlar canoe and the Toyota wagon. One particularly powerful gust jerks the canoe's bow askew. Stopping the car, I get out to tighten the ropes, giving extra tugs to the half-hitches. The car rocks in the wind, and the canoe strains against the ropes. I strain to control the ropes, the canoe, and my frustration.

Once at the Forest Service office, I cannot get a permit for Disappointment Lake, but I can smile briefly at the irony. My second choice is Wind Lake via Moose Lake. There is no one at the usually busy Moose Lake boat landing. The radio says the winds are blowing at 15-25 miles per hour. I push off, and am soon in big swells. More irony—fighting wind to go

to Wind Lake. The high gunwales and weight of my gear keep the canoe fairly easy to handle.

It takes me about an hour and a half to make three trips across the 175-rod portage between Moose and Wind Lakes. First I take the canoe, paddles, and a small pack; next the food and camping packs; finally the camera pack and tripod. At the end of the portage I stare into whitecaps, my hair blowing straight out behind me. I know there is a campsite at the opposite end of the island ahead of me. I head for it and hope it is unoccupied.

The next forty-five minutes I spend chanting a type of mantra. I simply paddle, count, paddle, count, paddle, count—inching my way cross the bouncing water. Slowly the island grows larger. I swing to the left, reach the other end of it, make a sharp right and sway in the rocking waves as I beach the canoe. The site is open.

For once the rain holds off until the tent is up, the food pack is hung in the trees, and the light dims.

I sleep a good sleep, and am happy.

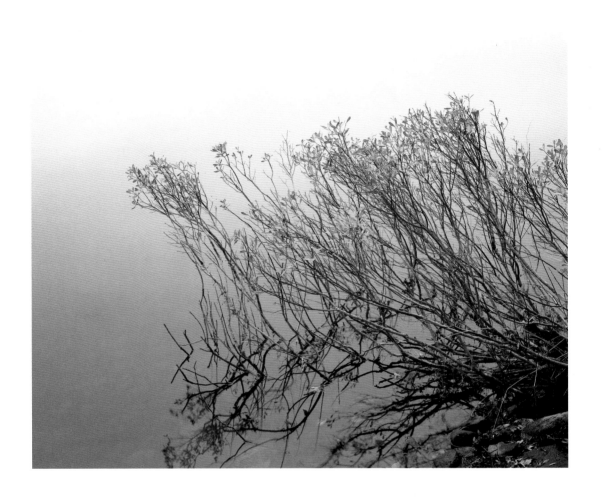

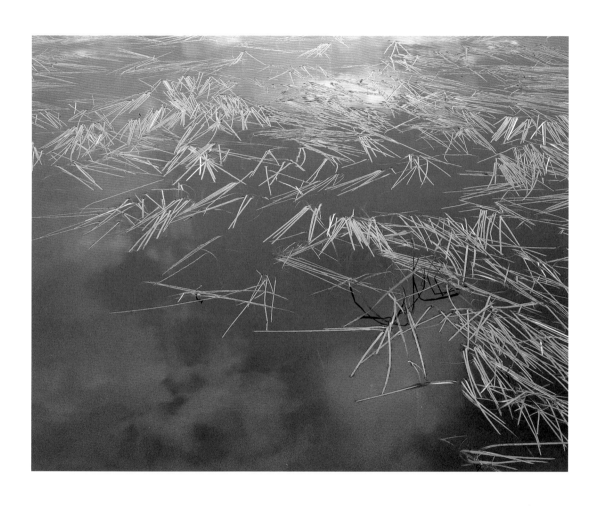

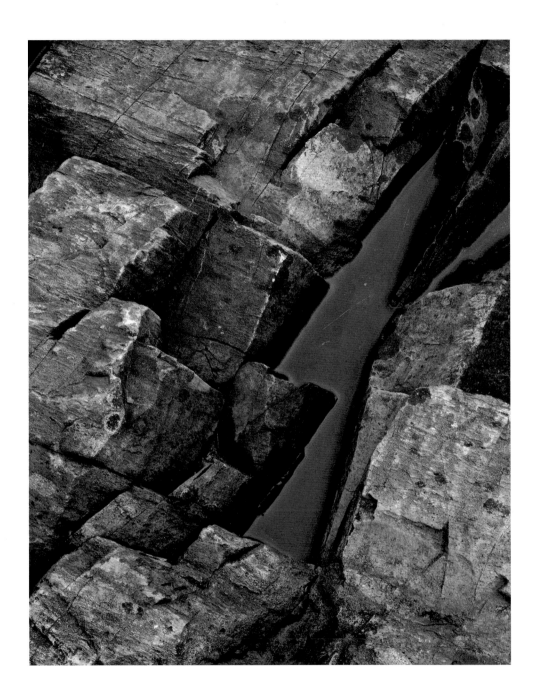

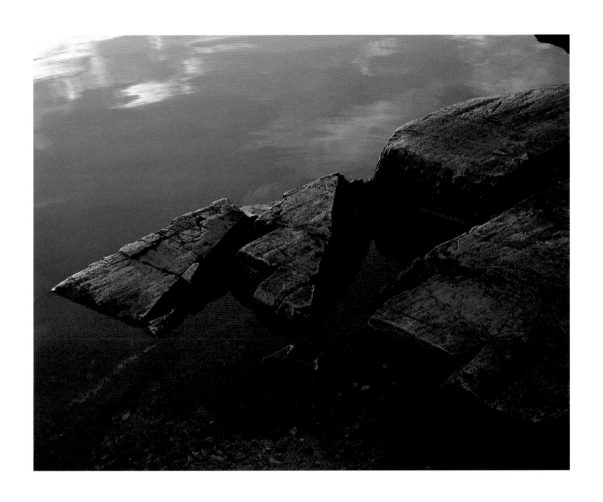

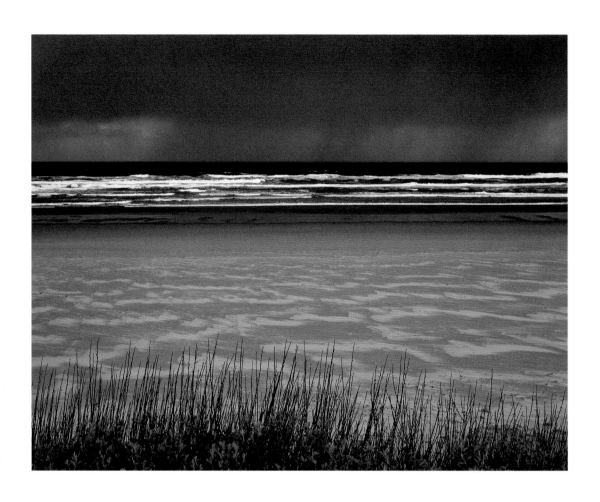

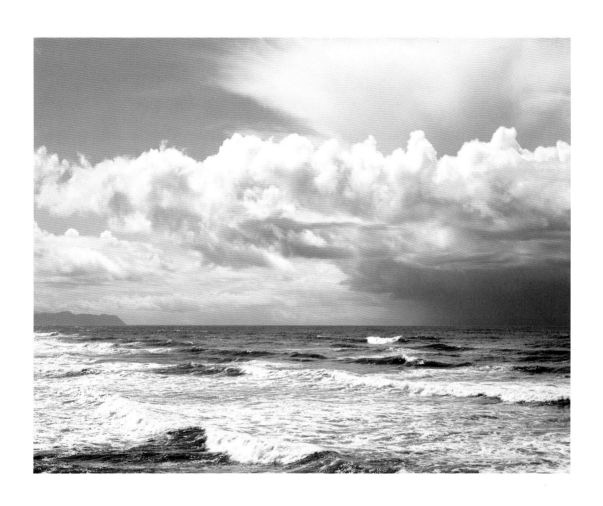

1989

Once started on *The Hidden Forest* book I warm into a comfortable working rhythm. The pace of solo canoe travel steps to the baton of the weather. My camp and packs are as ordered as my desk—I know exactly where everything is.

I choose my camps with an eye to possible photographs. Where does the sun rise, set? Is there a lovely old white pine, a glacially-scarred rock outcrop, a hill to climb, a mossy glen to explore, a graceful bay, a newly grown flower?

Curiosity and a willingness to explore are requirements for being a landscape and nature photographer. You do not bring objects into a room, and arrange them to suit yourself. You instead seek out from countless possibilities a "found" arrangement.

Acclaimed photographer Edward Weston, famous for his black-and-white landscapes, vegetables, and nudes, (who also photographed buildings and did color work for Kodak ads) said in 1930: "I get a greater joy from finding things in Nature, already composed, than I do from my finest personal arrangements. After all, selection is another way of arranging: to move the camera an eighth of an inch is quite as subtle as moving likewise a pepper."

And thus, when I find a group of pink lady's slippers blooming next to a stem with two of last year's seed pods, nestled within caribou moss and blueberry leaves, I look a long time, moving an eighth of an inch this way and that way until all the components are balanced and separated from each other. Here the camera will be set up. And when I take it down forty-five minutes later, and count the thirty or so mosquito bites on my hands and face, I don't mind the stiffness in my back, and the itching red bumps. I have enjoyed a visual feast firsthand, and it is on film for someone else to partake of, too.

Back at camp, I have another treat when I strip off my hot boots and socks and soak my feet in the lake.

The morning that I paddle out I meet no one. All is calm and still, the temperature mild, the air soft. My dog, now quite old, sits patiently in the bow of the canoe, enjoying the ride. I feather my paddle and slide it silently into the lake. We float along effortlessly. I think there has never been a more perfect moment. Wanting to prolong it, I let the canoe drift, and imprint the tableau on my mind. I have a sadness, expecting this will be the last canoe trip for Nuka. She's been all and more that every great dog is. Quiet by nature, she has a sixth sense about when we can play, and when she must not interrupt. When the tripod and camera are set up, she stays just the right distance away, never trampling through the composition, or bumping the tripod.

She becomes a statue until the photograph is made. She doesn't bark, and is discreet about bathroom matters, always going quite a bit off a trail to hide behind a tree, glancing back to see if anyone is watching. Her steady companionship through the years will never be forgotten.

My reverie ends as it starts to sprinkle. I paddle faster, and reach the portage just as it rains in earnest. The car is at the other end of the eighty-rod trail, so I move gear rather than wait. Once everything's in the car, except the wet dog, it stops raining. I'm glad—I can now go back along the portage to photograph a group of bunchberry flowers freshly wet and impeccable. Nuka, as always, waits a few feet away. By the time I'm finished she's dry, and the sun is shining strongly.

After so many canoe trips, it's nice to do some car camping, and to also base out of a motel, cabin, or friend's home occasionally. In late June I stay with a friend in northwestern Minnesota. She enjoys photography and has done some research for me. We drive together to likely locations, and she is happy to either sit and read, do her own photography, or be an extra set of hands for me. The trip is a productive one, and one of the most special photographs is found by chance. In a roadside ditch I spot a stately bouquet of showy lady's slippers. It's high noon and the light is harsh. My friend helps me arrange a large diffusing tarp and dark cloth to modify the light, and I make the photograph.

It seems, though, that the North Shore of Lake Superior and the Superior National Forest are the places I mine most for photographs. I am aging along with these places. I notice if a young tree has grown to block a view, or if an old tree has fallen. I stroke a familiar rock surface and feel a deeper erosion in one of the grooves. I place my hand on another section and know I cannot discern what minute change has occurred since last I greeted it. Finally I stretch out on the rock, close my eyes, and feel its timeless, solid support.

Opening my eyes I look at the sky. It is growing dark. Shouldering my camera pack and hefting the tripod I go back to the car. No one else is at the trailhead. I fix a quick supper and finish eating just as rain begins to fall. I will be sleeping indoors tonight. As I lie in bed later reading to the sound of rain against the window, I am satisfied with the day's work.

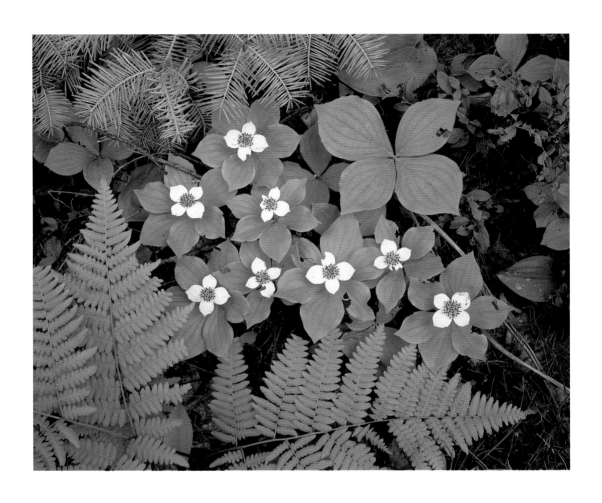

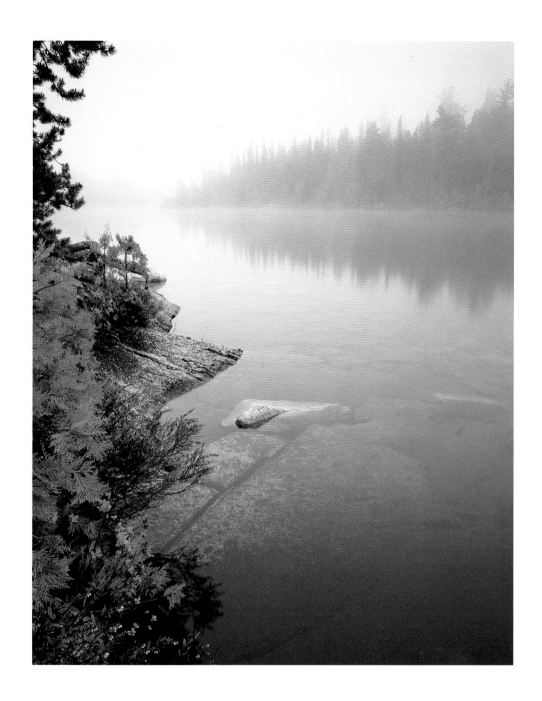

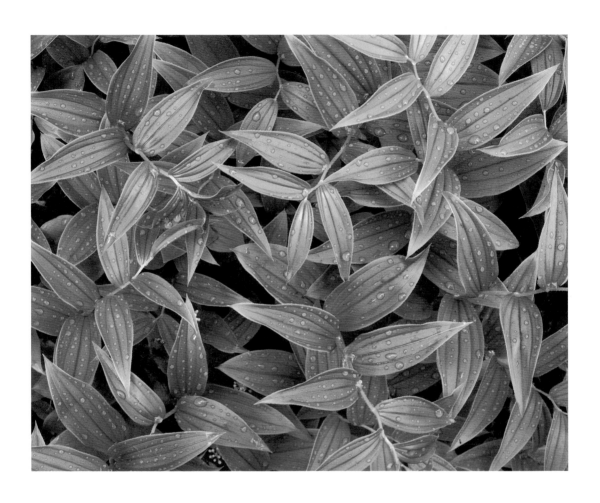

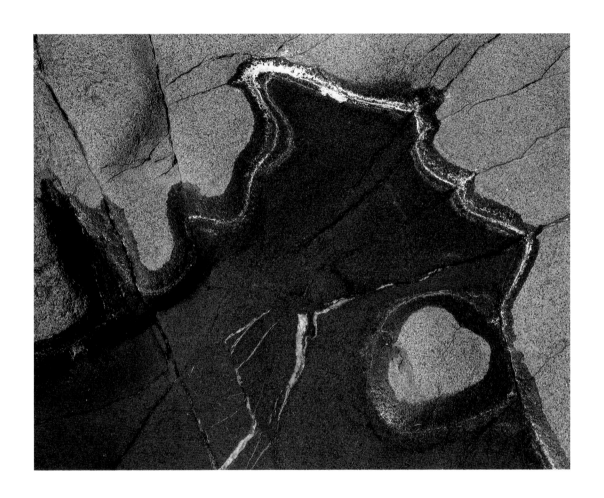

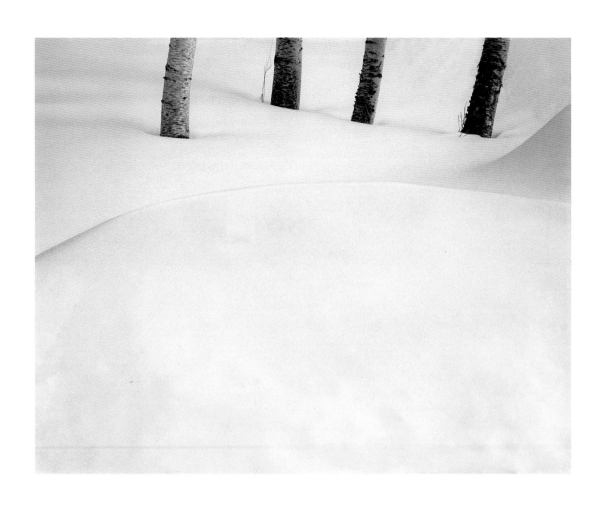

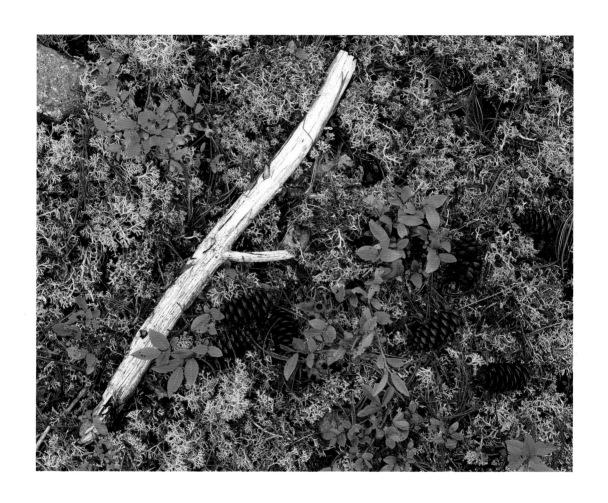

1990

Layout work begins on *The Hidden Forest* book. The challenge of fitting all the pieces together is one of the most satisfying parts of a book project. We have large windows in our house, and they serve as giant light boxes at this point in the process. Transparencies are always in sleeves, and are taped against the window. It is a way to try each one against the other and see the whole sequence at once. Moving, mixing, looking, waiting to see if an instant match still looks good later. One change causes others, like in a row of dominoes. Rarely is the whole order uprooted, but sometimes it is. It's important to remain open-minded to new possibilities and other points of view.

We are invited to speak at Carleton College on the twentieth anniversary of Earth Day. It is a real eye-opener to watch the students' faces as Craig and I talk about what we each did on the first Earth Day. Somehow we had forgotten until this moment that these grown people were not even born in 1970.

Activities like this reduce time in the field photographing. When we are both gone during weeks of teaching or a joint trip, mail piles up and occasionally business is lost because we are not there to handle a request. We learn to accept the limitations.

In July we make the heart-breaking decision to put down our almost sixteen-year-old dog Nuka. The piercing pain and grief is overwhelming. The day is spent in silence.

We throw ourselves into work again, first teaching for the University of Minnesota's Split Rock Arts Program, then I go to Itasca State Park to work.

It's been years since I've been to the park so I enjoy exploring it. I set the alarm for 4:00 a.m. one morning so that I can be at the headwaters of the Mississippi River before dawn. Wisps of fog float on the water. No one else is around. My fingers are chilled, and there's hardly enough light to take a meter reading. Gradually the sky brightens, and I am like a runner in the starter's block waiting for the "gun" of sun to fire. When it does, I release the shutter and whip out the film holder to shoot again. It jams. It absolutely jams. By the time I've fixed it the light has changed. I photograph again, but the aggravation has temporarily ruffled my mood. Just one of those things, like the fish that gets away. Or so I tell myself.

In September I am again on the North Shore during prime fall color. It is an almost annual event, and just as anticipated as any favorite outing. I walk familiar trails and check if a clump of club moss is undisturbed. I notice how much a juneberry shrub has grown. I wonder if anyone else takes the same delight I do in a "character" tree.

The year ends with another almost annual event—rounds of booksignings. It has been years since we've decorated for the holidays. We are not home often enough to take care of or enjoy a tree. My life is filling with other memories, like those of the trip I took to Scotland in early September.

I travelled to the Isle of Lewis, the outermost of the Outer Hebrides. I wanted to face the ocean with the sense of being at the edge of the earth. The island is stark, isolated, thinly populated, raw, and seemingly innocent. Peat smoke scents the air; sheep block the narrow tracks that serve as roads. A lone red phone box serves a small group of houses.

This time I am with a friend originally from Canada. People think we are Canadian instead of American. In a pub where we stop for lunch, we hear some unpleasant comments about Americans—true of some individuals, of course, but not true of all of us. We gently attempt to educate, and then tell our fellow diners we are Americans. The conversation shifts to geography, and when one old sailor learns I live about fifty miles south of Duluth, Minnesota, he says, "I've been there, at the end of Lake Superior."

Although I have only a point-and-shoot 35mm camera along, I am constantly seeking images. I thrill to the multi-colored ocean, the vast unmarked beaches. As I compose one image, I fill the frame almost entirely with sueded sand. A strip of ocean and distant velvet green headland edge the top of the image. Strong light renders these elements emphatically taupe, azure, emerald. There is not another person in sight on this perfect beach this perfect day.

The best things about my travels, whether with a friend or alone, are the chance conversations, the satisfaction of finding my way around a new place, tasting something new, and, most importantly, imprinting it all in my memory. Each encounter is a layer of humus for the growing, living matter of my life. It doesn't matter whether I'm half-way around the world or just a few miles from home. If I haven't been there before, I am offered something new. All I have to do is take the opportunity.

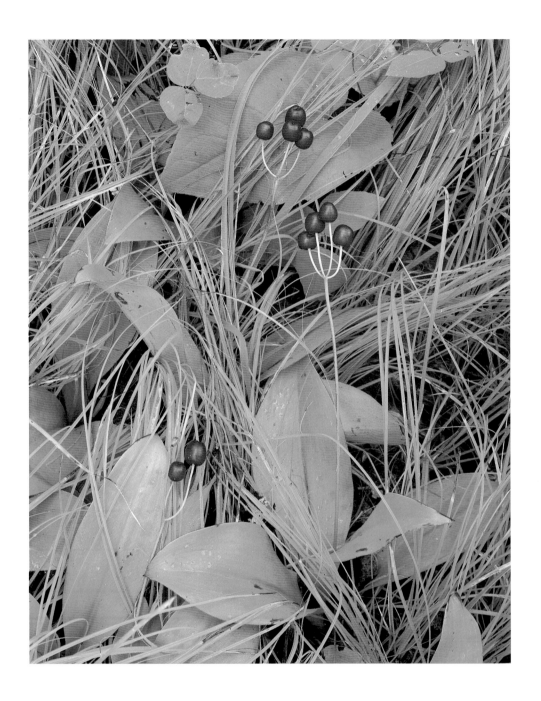

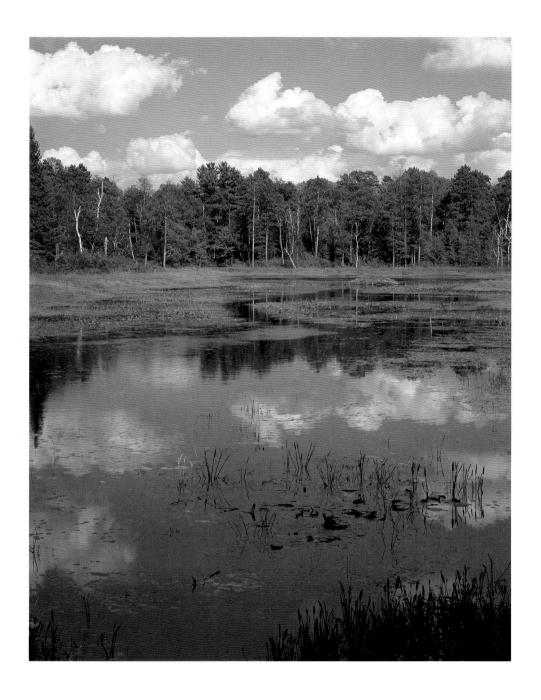

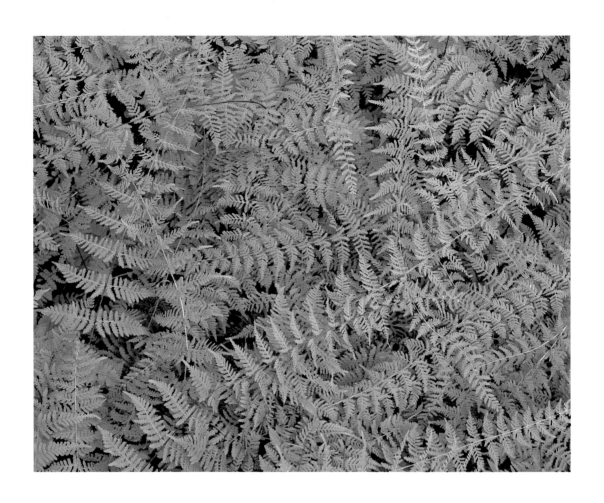

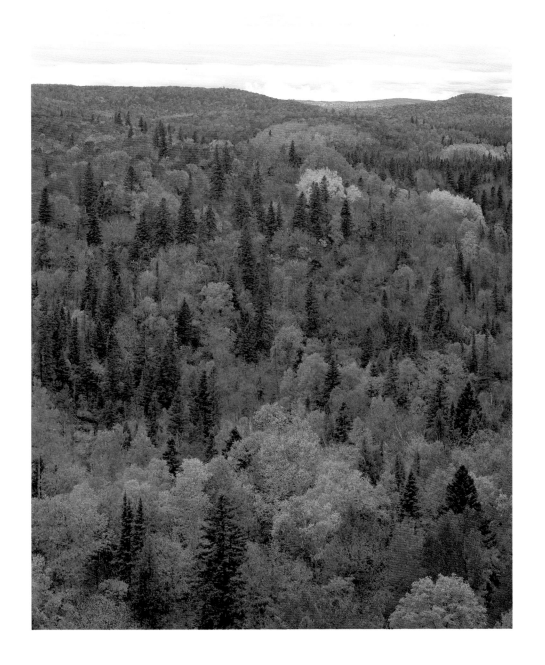

1991

I am happy at the start of this year. After six months without a dog, we come home one evening with a new black lab puppy we name Paddles. (We picked the name back in 1987 paddling across the last lake on our last canoe trip for the *Border Country* book. Our old dog Nuka was sitting in her usual position in the bow of the canoe, her ears flying out in the wind.) Labradors love to do the dog paddle, we paddle canoes and kayaks—it just seemed like the right name. Paddles lives up to it, too. She throws herself with equal abandon into any form of water, whether lake, mud puddle, or snow bank.

The same week we get Paddles we pay off our mortgage and celebrate our sixteenth wedding anniversary.

The overriding event of the year is Craig's circumnavigation of Lake Superior from May through August to finish photographing for *The Lake Superior Images* book. It is a major job to plan the logistics of this 100 day, 1,200 mile trip. My role becomes one of wearing all the hats for both of us regarding the business and other aspects of our lives.

As frantic and sometimes frustrating as the summer is, it is also exciting and hopeful. I don't have much time for my own photography, but compensate by taking the cameras with me almost everywhere so that I will be prepared to work whenever an opportunity arises.

For me, a big part of each photography foray is the hunt for new places. When I find one I like, I next hunt the pieces of the place. I expect that around the next bend or over the next hill a jewel may be found. Sometimes it is at my feet, sometimes above me, or directly in front of me.

Walking the shoreline of Lake Superior near Grand Marais, I find a cleanly-edged section of rock wall with tracings of lichen growing along hairline cracks. The void where a section has disappeared is cut at perfect right angles. Shadows expose the three-dimensional form, raw sunlight warms the rock and defines the texture. The bold play of light and line holds my attention. I explore it first with my eyes, then when the film is exposed and the camera put away, I run my fingers along the lines and edges, feeling the warmth, the coolness, the smoothness, the roughness.

I drive up to Split Rock Lighthouse State Park in late August to bring Craig home. Paddles comes along, bouncing between the back seat and the front seat and the back seat again, bumping her slimy nose against every window in reach. When the car slows to turn into the park she barks as energetically as a ten-month-old lab can. The reunion is sweet

and warm—hugs, tail-wagging, and stories. I think about how many times in how many seasons I've been at this beach and in this park.

Birch trees are favorites of mine, and Split Rock Lighthouse State Park has had a multitude of them. Disease and insects, though, have decimated the stands. Birches are not long-lived trees even in the best of conditions. I feel a sense of urgency to photograph particularly stately trees.

Autumn, when the forest floor becomes a mosaic of colors and textures, is my favorite time of year. I find elegance in flora settling, sinking into graceful repose on the ground. Equally mesmerizing is watching the forest reveal its bones as it sheds its skin of leaves. Flashy colors dim then disappear. Every hike with the camera is rewarding.

A drastic change of scene awaits us in September when Craig and I go to southwestern Minnesota near Pipestone to both photograph and teach a weekend workshop. Fires burning in Yellowstone National Park taint the sky even here. Yellow-pink haze adds a surreal sense of times past. I expect to hear herds of free-roaming bison drumming the ground. Instead, only a breeze whispers. I expect to hear a horse's whinny. Instead, a jet's whine draws my eyes up to a pencil-thin vapor trail tracing the zenith.

As I walk among waving prairie grasses, I think about the metaphor of prairies being like oceans, think about how deeply loved prairies are by the people who love them. The prairie has its appeal, but I don't love it. My strongest connections are to lakes, trees, the forest floor—and to the mountains and oceans I first saw and fell in love with in my twenties.

What we feel the deepest for, we use to express ourselves.

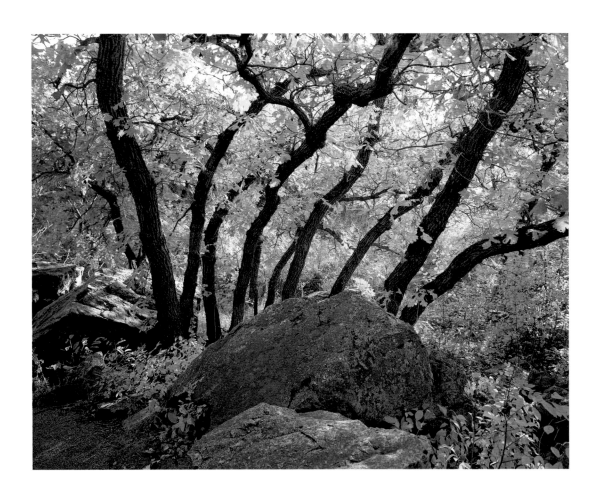

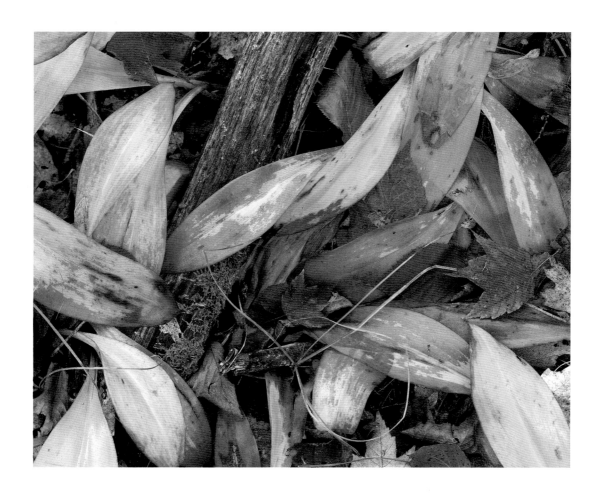

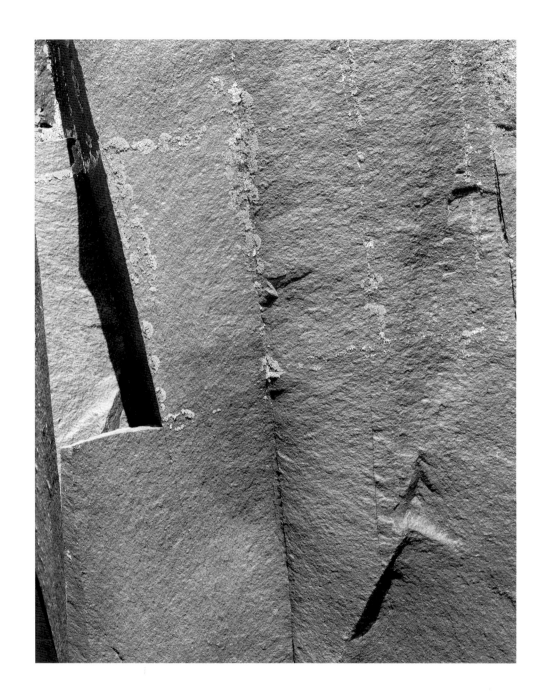

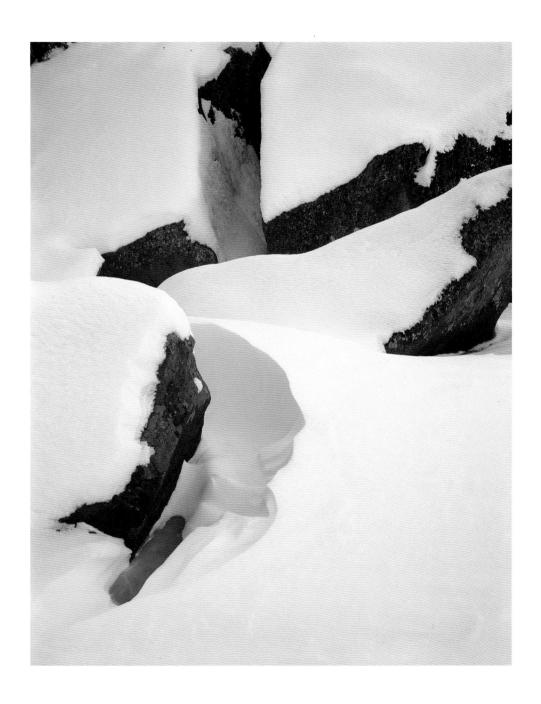

1992

As is often the case, the older Craig and I get the more involved we become in everything from work to causes. Our schedule is overfull.

Teaching in recent years takes us outside Minnesota and Wisconsin to Vermont, Chicago, Toronto. Our photographs, too, have been exhibited outside the region—Portland, Oregon; Cambridge, Massachusetts; Washington D.C.

We have signed a contract for books with Pfeifer-Hamilton Publishing in Duluth. The books will be small compared to *The Lake Superior Images* book. I like the shift to a narrower focus. The first book is on Gooseberry Falls State Park on the north shore of Lake Superior. The park has over a million visitors each year, and is well-loved. Too loved, actually. Heavy foot traffic near the falls has eroded the soil and exposed tree roots. Cars almost continually line the highway on both sides near the falls. Often a carnival atmosphere invades this part of the park.

Like almost anyplace, though, once off the beaten track, even in July, I can lose the crowds. Some trails get little use, some shoreline is rarely explored, and if I get up early enough, I can even have the falls to myself.

After the wilderness camping we've done for the *Border Country* and *The Lake Superior Images* books, camping in a state park feels like being in the middle of a city. While it's nice to use a tent big enough to stand up in and to sit at a table to eat, I'm irritated by noisy generators in the big RVs, too much campfire smoke, and people singing way into the night.

I retreat inland to work along the river, letting the rushing water cover traffic noise and conversations. Photography allows me to paint with this moving water. In cloudy light or in shade, water is rendered in soft milky free-forms when a slow shutter speed is used. Very long exposures turn water to silk. Sunlit water, by contrast, will be electrified with scintillations. The naked eye cannot see these effects.

I also work at the mouth of the river. Its context continually changes as its bar is tugged one way and another by wind, waves, water level. One afternoon I am standing partway in the river, composing an image looking out to the lake. The bar points in from either side. The river and lake are calm. I cannot discern where one really ends and the other begins. It is this calmness and the minimal elements that attract me today—they counter the seductive wildness of adrenaline-producing storms.

One evening the sky darkens instantly with black-green clouds driven by intense wind. Puddle-size rain drops assault the tent like a drummer's sticks beating a snare drum. A nearby birch tree succumbs to the blast, dropping to the ground with an earth-shaking thud.

Buzzing air crackles a moment before lightning discharges. Thunder, like a whip, snaps, rumbles, whishes, snaps again.

Then as quickly as it comes, the storm moves on, speeding out over the lake. I leave the tent. The last whispers of wind sneak under my hair, brushing the back of my neck, raising goosebumps, spooking me.

It is very dark now. I slide and shuffle more than walk on the slippery path and wet rock as I make my way to the shore.

Silence. Crisp air. A growing murmur. Waves slosh arrhythmically against the rock. Clouds tumble over each other, receding, mesmerizing. I am witnessing a clean sheet being pulled across the sky. I think I am alone.

One tardy burst of lightning shows me I am not. Many other people stand speechless, looking east, watching.

Storms speak to me. Their boldness, brashness, and brevity demand engagement in immediate transformation. Dead wood is flung away, a flower prematurely flattened, a channel widened, a beach washed clean, roots exposed, pools created.

The urgency inherent in storms is a balance to the slower evolution of the seasons. Both are rich mines for me: I photograph the spent flower, the perfect flower, the bug-eaten leaves, the complete leaves, the dark sky and the sunny sky, the imminent rain, the clearing clouds, the smallest lichen and the grandest landscape.

Different days all these pieces fit together in different ways and I see them differently. Nonetheless, I hope to leave my individual mark consistently, regardless of its shading. And I likewise enjoy finding a consistent thread when I examine another person's body of work.

I think we look at art both for a reflection of ourselves and for insight into others.

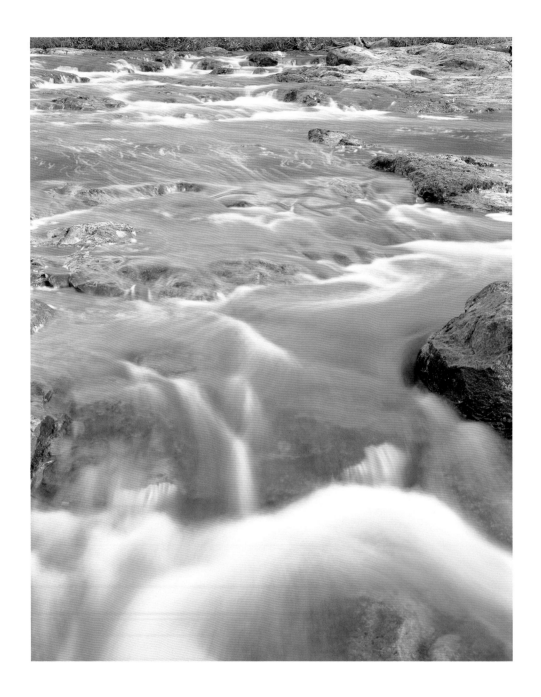

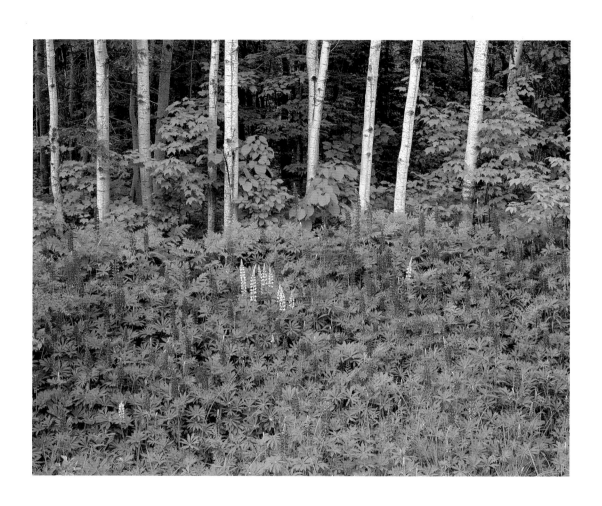

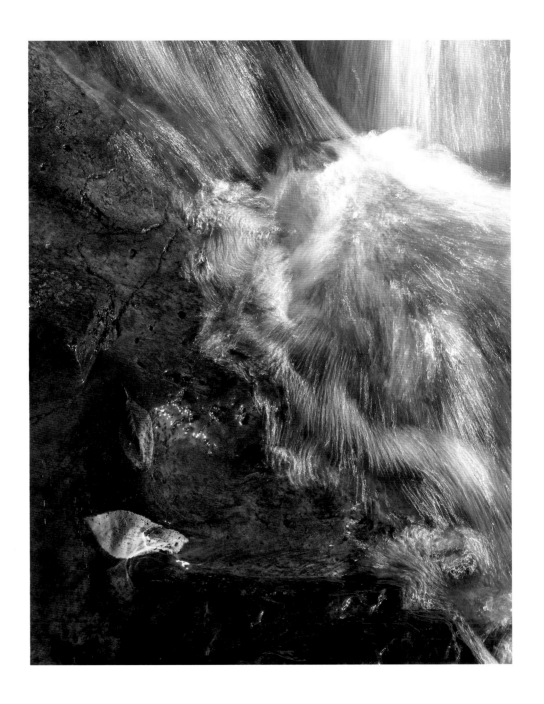

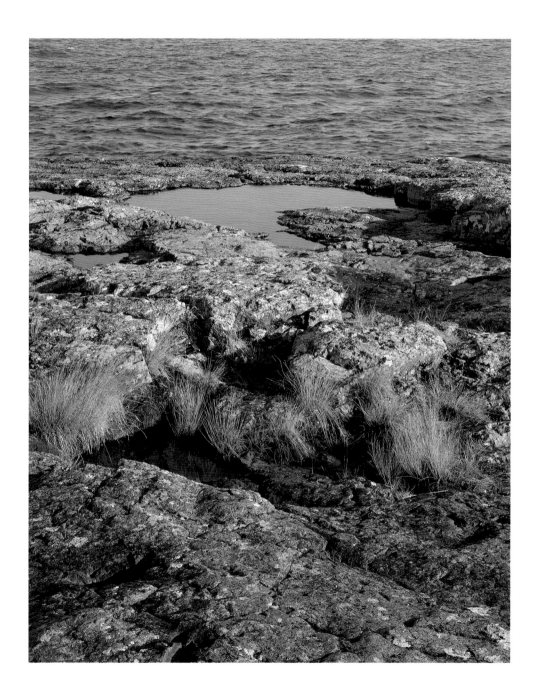

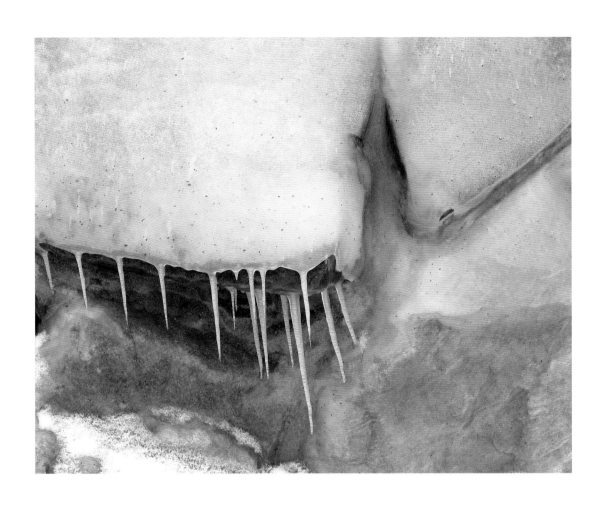

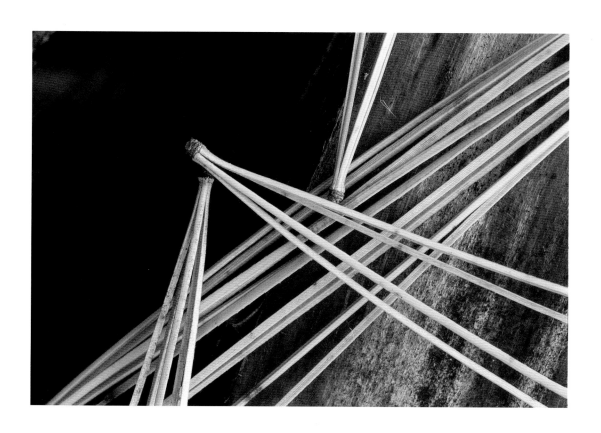

1993

This year we finish photographing for the *Gooseberry* book. We are also working hard on the pre-production stages of *The Lake Superior Images* book.

I have little time for photography after March. I expend great energy and time editing Craig's text, discussing and trying various sequencing of the 154 photographs in the book, finalizing the design and specifications, looking at proofs, keeping the house and business daily affairs in order. To me, that's what spouses and business partners do, with the expectation that a give-and-take balance will occur and a long-term commitment exists.

In May we go to Seoul, South Korea, to oversee the printing. The trip is physically exhausting but emotionally enriching. The graciousness of our hosts at the printing plant, sightseeing in the city, new foods, new beverages, new customs, new language—all add to our life experience in a way that can't be explained to non-travelers.

When we return, we continue work on the exhibition of prints at the Tweed Museum of Art, advertising plans, and booksigning schedules.

Sandwiched in with these responsibilities are meetings on the *Gooseberry* book, increased environmental volunteer work, and speaking and teaching engagements. Later in the year, our lives are overtaken by activities relating to *The Lake Superior Images* book. The wonderful news is the book's reception—strong enough that the first printing sells out in twenty weeks, and we make arrangements to go back to Seoul in January, 1994, for a second printing.

1994

Our projects have been rolling over each other to the point it's become crazy. We decide it has to stop. Some of the joy is going out of the process. In addition we have taken on major volunteer responsibilities to environmental organizations, and our elderly parents require more of our time and care.

Does all this affect my work? Of course it does. I worry that I am becoming jaded, and that my work might reflect that. I don't want that to happen. Something must change.

Basing photography primarily on book projects means a long time line must be considered. It is something akin to piloting one of the mammoth ocean-going ships that ply Lake Superior. A great deal of space and time is needed to change speed and direction.

So a decision in 1994 to slow down the book creation plan does not affect reality of daily life until 1995 and 1996. The book being worked on in 1994, *The Duluth Portfolio,* will be in production in the winter of 1995. We will go to Seoul for printing in 1995, and do the rounds of booksignings, talks, interviews in 1995.

The success of *The Lake Superior Images* book brings more requests for programs and calls for photography. A busy schedule gets busier.

Unexpected opportunity to buy nearby land sets off a chain of events that culminates with our family starting a non-profit organization. Tremendous effort goes into this. A month or two later, I become president of another organization, while still on other boards, finishing production work on the *Gooseberry* book, doing photography for *The Duluth Portfolio* book, and working seven days a week to do it all.

Field time with the camera is relative respite, plain and simple.

One morning I find a small, delicate wood anemone not fully open. Instead of hurrying, as I often do when the rest of my life is in high gear, I slowly set up the camera and tripod. Sitting on the ground, I direct all my attention to the composition. When I have finished photographing, I look awhile longer through the viewfinder, letting the soft pastel pink petals soothe my eyes and mind.

I find a similar sort of peace another day on Minnesota Point when the dew is not yet off the blueberry leaves, and fog has not left the forest. These moments and the accompanying sense of order and completion are short-lived.

In spite of intentions, the year ends with a pace much too fast.

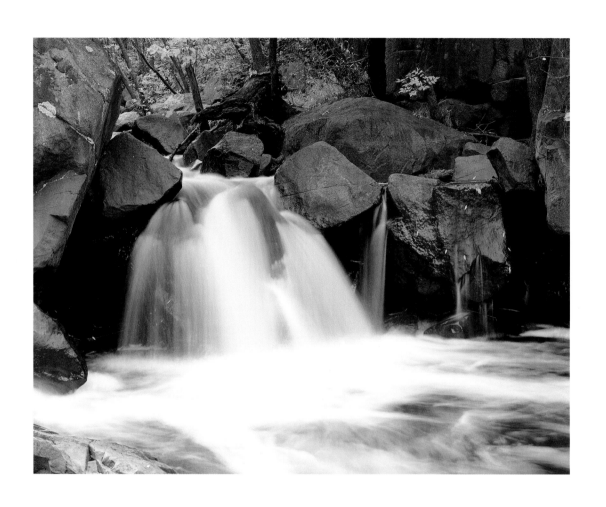

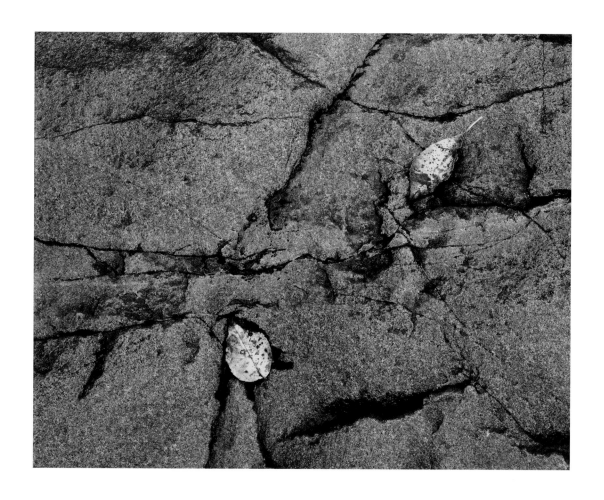

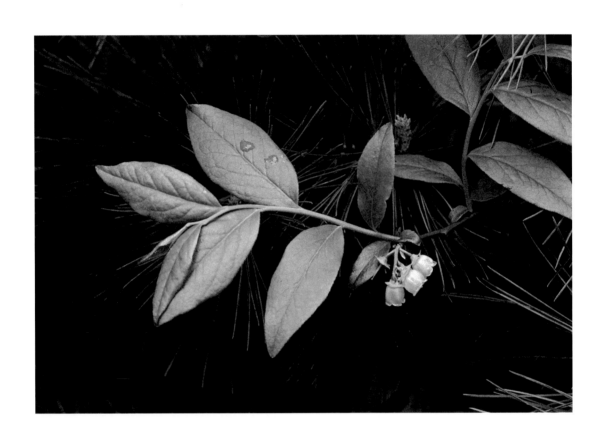

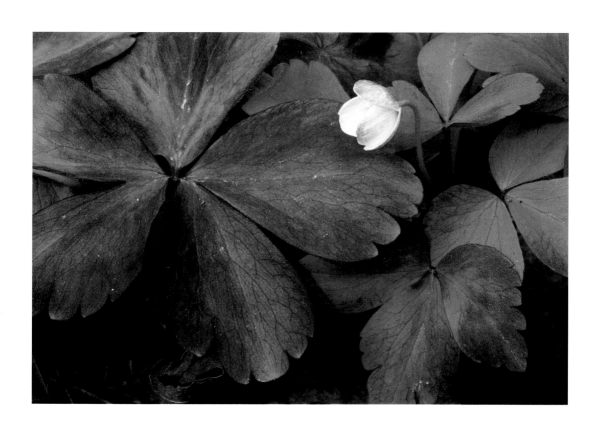

1995

Photography time is again reduced this year when Craig and I accept an opportunity to design a product catalog for a company. We are intrigued, both by the chance to do something different and by the fact that payment will be received in the same year the work is done, unlike book projects, where royalties don't start until six to twelve months after a book reaches the stores.

We think we will have enough time to do this because we are not involved in a book project. We discover that the task of fitting our tastes with a client's can be delicate. Much more time than expected goes into revisions.

My father-in-law Les, who has Parkinson's disease, is now in a nursing home after breaking his pelvis. More of our time goes to him and Fran. Les dies one evening just minutes after we leave his room. Even when death is expected, and for the best, the grief is no less severe.

Two mornings later I go out with one of my cameras, a big studio 4x5 camera that once belonged to Les. The bur marsh marigolds in a swamp close to home are in their prime. It is a calm, clear morning. I go through the motions of positioning the tripod, hefting the heavy metal camera onto it, fitting the lens board into the front standard, cranking out the bellows to the approximate length, throwing the dark cloth over my head, and examining the ground glass. I swing the camera right and left as I fine-tune the edges, and then check the composition with a mirror. (On the ground glass of a view camera, the image is upside down and flopped. The mirror puts it right side up, but still flopped.)

After putting the mirror down, I take out the loupe (a magnifying device) and focus. When swings, tilts, and aperture are where they need to be, all controls are tightened. Next the cable release is attached to the lens. Each part of the composition is read with the light meter, the exposure figured, the shutter speed set, and the shutter cocked. A film holder is inserted in the back of the camera, and the dark slide pulled. Then I watch the light and wind movement, and wait. Sunlight has not yet reached the swamp. I make an exposure, put the dark slide back in, pull out the holder, reverse it, insert it again, pull the slide, recock the shutter, wait, and expose.

Now the sun's first soft, low-angle rays reach the composition. The yellow flowers glow. I quickly get another film holder, and photograph again and again.

The light loses its softness, and the moment is gone. I stand and look longer, thinking of Les, feeling that making a photograph today

is somehow a tribute to him. He would have enjoyed this morning, exclaiming over the flowers, admiring the profusion of blossoms.

Losses are cumulative. The older we become, the more we know what they are, how they feel, how long the pain lasts. We also learn the truth of "Time heals." Layer upon layer of life settles on us, like thin sheets of parchment. Weightless and weighty at the same time. The big losses drop like boulders, but the strength of the many layers holds. We bend, bruise, ache, but we don't break.

How does this change me? I recognize the gifts of getting older. I really do feel I have begun the second half of my life, and I am happy to be on a plateau to rest a little. I appreciate everything in a slightly different way. I have long believed if you don't take care of yourself, you are no good to yourself, anyone else, or for anything else. So I do my best to put leisure time higher on the priority list, even if it's only a walk with the dog, reading a chapter in a book, or fifteen minutes playing the piano or saxophone.

In the field with the camera, this translates into not trying too hard. It means believing more and more that just being out there leads to wonderful discoveries.

Is it true we make our own luck? Probably. I know that many times by concentrating on my surroundings I find my eye drawn to several things. It is the opposite of tunnel vision. It is maximizing peripheral vision, and using hearing and smell to find what may be hidden from the eye. I achieve this state best when I am alone.

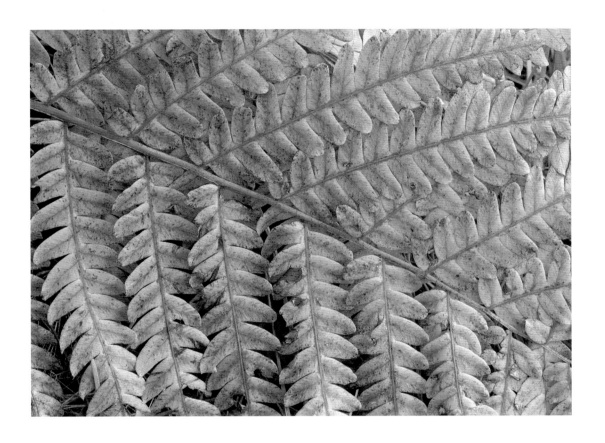

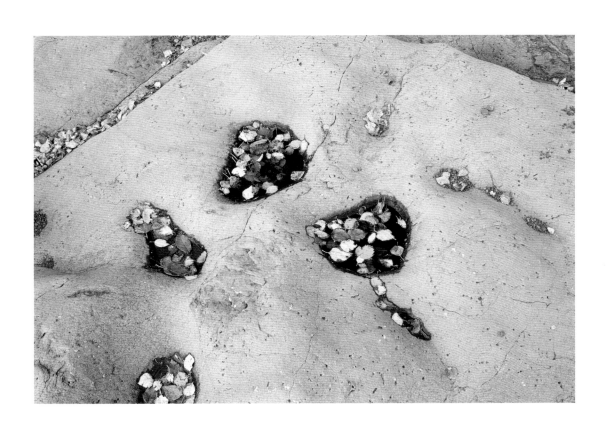

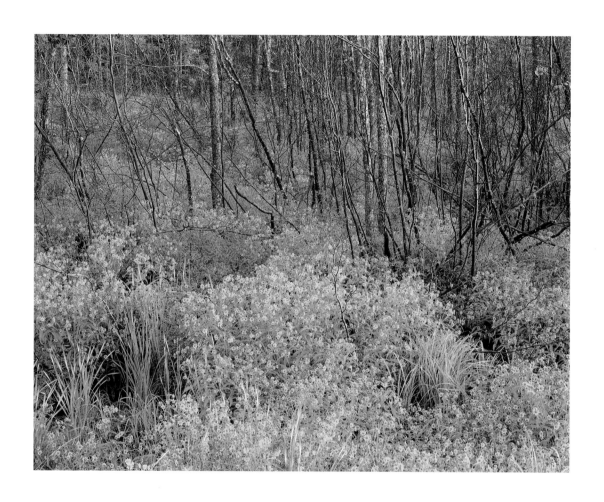

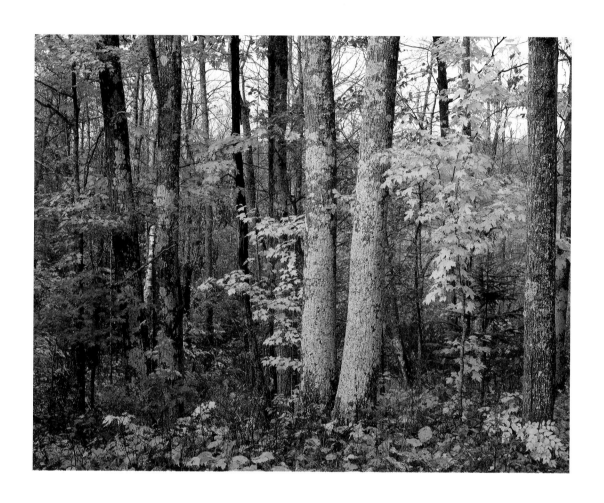

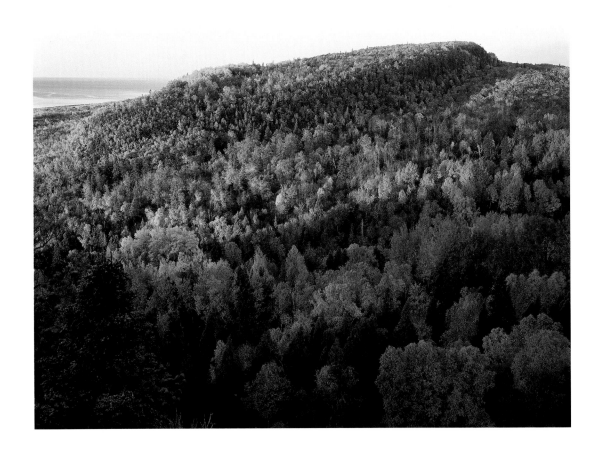

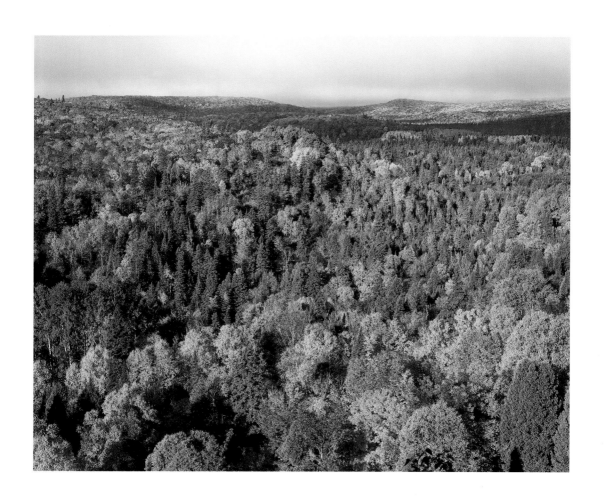

1996

I am a believer in rituals—not the big kind, but the little kind. Small touchstones, small remembrances like a certain wine for an anniversary dinner. Perhaps because nature is so big a part of my life and my work, and where I have been happiest and saddest, it is where I do my best thinking, best grieving, best remembering.

I listen to the wind, reach out to the warmth, the cold, watch the light play itself out over the landscape, let the rain moisten my hair. I walk. I sit. I wait. I let the emotions course through me. I start to create new memories.

One place I am most at peace is Oregon. I fell in love with it in 1982 and have been back many times, but not with the big camera.

This October, though, I take my view camera with me. I go for a week, wanting to work, to feel the centering that occurs when I am immersed in composing.

The trip is a balm in more ways than one. In my plane seat I am released from the earth, transported by the thrusting climb, then soothed by the weightlessness of level flight. With a pillow behind the small of my back, another behind my head, a blanket across my lap, I close my eyes and rest.

I rarely make lodging reservations when I fly to Portland. I take my cue from what I see as the

plane passes over Mt. Hood. If the sky is clear I head straight into the mountains, if not I go to the ocean. In recent years I've had perfect weather and I'm concerned that this time, because of the law of averages, I may not be so lucky. I'm right—first comes the turbulence, then I see nothing but solid clouds, and it's raining heavily as we land.

I stop for lunch at a hotel next to the airport. I buy a newspaper, and turn to the weather page. The forecast is not good. I next call the weather line. There is a winter storm warning for the Cascades, with the freezing level at three-thousand feet. The coast has seventy-one mile per hour winds. More of the same is forecast for the next few days. Right outside the window it is dark as dusk, pouring rain, and the trees are jerking crazily in the wind. For a few minutes I am stymied. I am shut out of the mountains, and I won't be able to stand up against those winds at the coast. So where do I go?

Always, there is something that can be done, something to be found, some pleasure extruded. I take the newspaper back to the hotel lobby, sit and pretend to read it while I sort my options. I will go to the coast.

I decide to stay somewhere I've never stayed before, an older place on the beach. That night the wind shakes the walls and shouts louder than the waves. The power is contagious, and suddenly I am grinning. I think of other times

I have reveled in storms, standing full face
into the wind, enjoying testing my strength,
and filling my lungs with force-fed air.
I sleep soundly.

As I have learned, being present and ready
means I find unexpected gifts of eye-stopping
elements to work into compositions. These
compensate for the preconceived images that
I don't get because the light is wrong, the tide is
too high when the light is right, the old favorite
tree has fallen, or a dog has just run through the
sand and made tracks.

Early one morning before the sky's color cools
into full blue, I hike out on the dunes. Last
night's storm brushed the sand clean of tracks
and groomed the grasses. The soft light suits the
subject. I know I have only a short time before
the light will flatten. I enjoy this sense of
teamwork with the natural world. Observation
and planning, scouting and watching, following
patterns from day to day, year to year—it all
primes my vision. It enables me to be where
I can find what I seek.

The play of light and shadow, of rock and
water, of sky and earth, of wind and calm,
of color and absence of color—is for me like
the painter's paint, the potter's clay, the writer's
vocabulary, the composer's melody.

As I set up the camera to work in the forest, or
bend over the ground glass while working with

beach stones, I am stretching to create another
image that speaks of both connection and
independence, transience and permanence.
A photograph is a moment preserved. The
viewer rarely knows what precedes or follows
that moment.

One morning, deep in the ancient forest, my
exposures run to two minutes. I am still, the
wind is still, no one comes, no bird sings, no
creature moves, nothing disturbs me or the
moment. There is time to expose more
than once. This calm lasts for much of
the morning.

I continue a visual searching even when the
camera is not out. I spend long minutes with
eyes and ears fully engaged with the environment.
This extra sensitivity stays with me as long as
I am alone. I give more attention to each bite of
each meal. After a brisk walk in the mist I am
doubly appreciative of the coffee
I pour from my thermos.

So, yes, I find something; yes, I feel unexpected
pleasure; yes, there is more to come. I recognize
the dignity and integrity in nature and its cycles.
I will continue to follow what I can and capture
what I can on film.

I will continue to compare perception to
reality. After all, who can say with certainty
what each is?

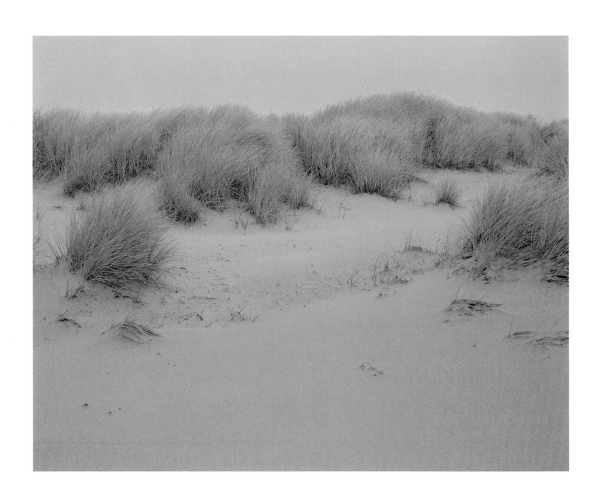

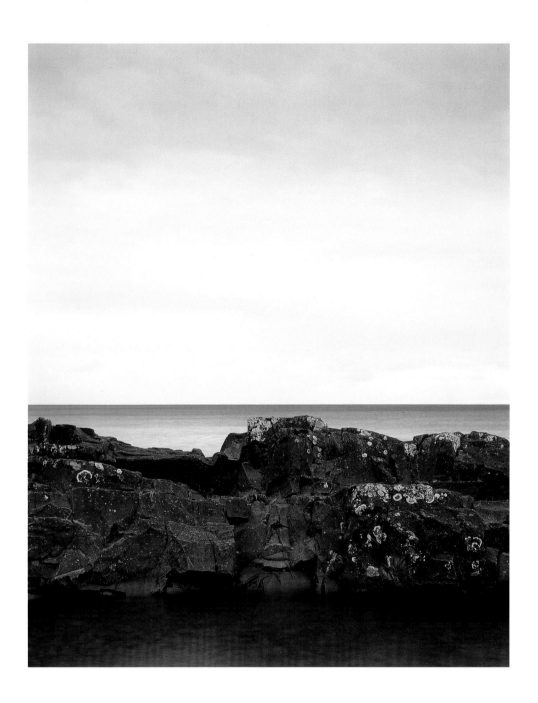

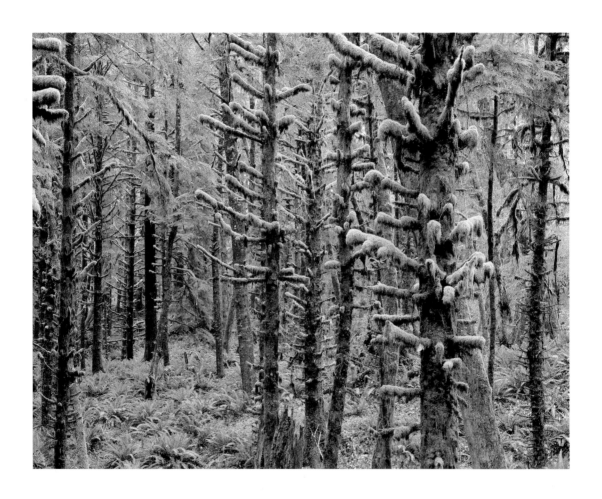

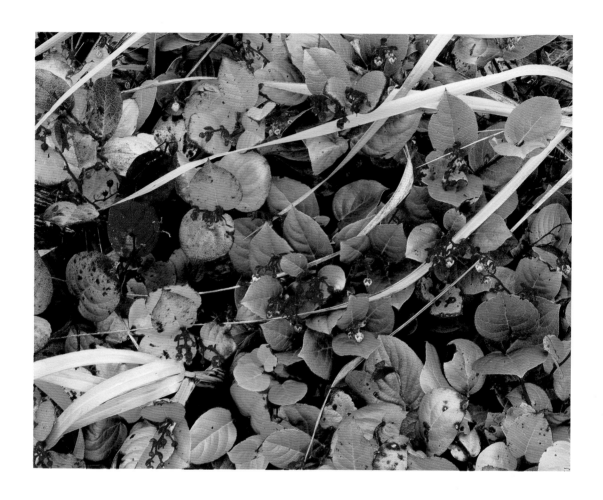

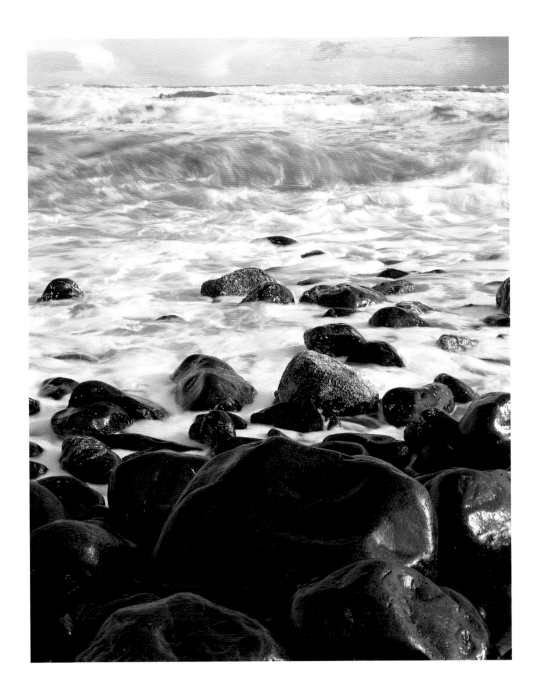

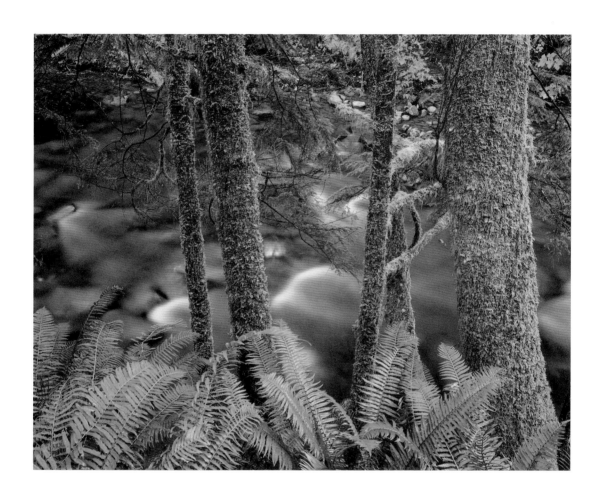

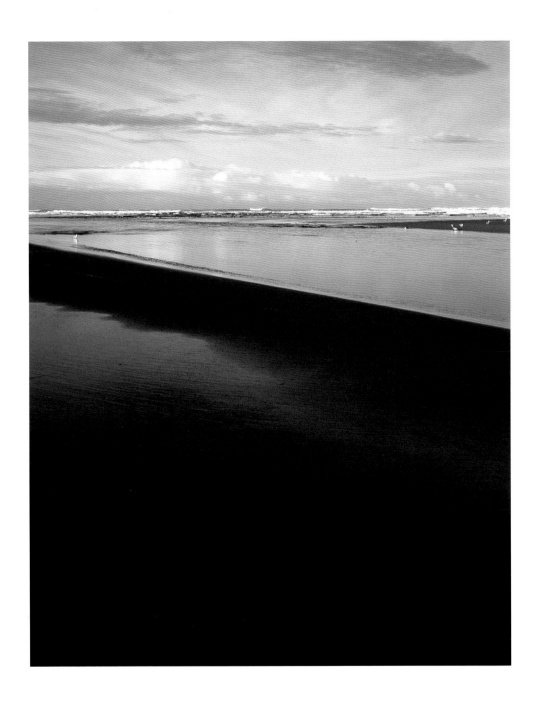

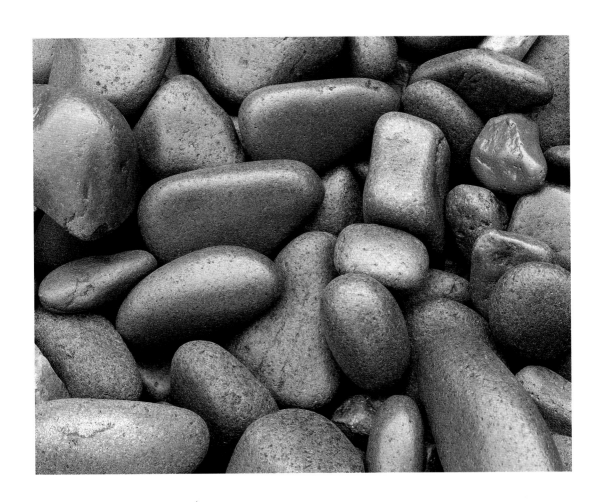

Epilogue

Is a picture worth a thousand words? Its literal translation might be; but to know why a photographer makes an image, not that many words are needed. Most of us do it because something about a combination of elements entices us to do it. For me, that something is balance. There is peace in balance. I choose the balance found in nature—rather than cities, people, or events—because I like working alone and unobserved. I like how I feel when I am outdoors. I like the infinite lines, curves, tangents, colors, and textures nature offers. I like watching a viewer discover balance in an image that they first thought chaotic.

Honing this balance requires my full concentration. To delete non-essentials from the composition is challenging, sometimes frustrating, but tremendously satisfying. I am not conscious of time during this process, except when I am in a race with fast-changing conditions. I know I cannot always fully control the light, wind, clouds. Sometimes I miss the window of opportunity, and the image exists only in my mind.

I first held a camera when I was twelve and decided about three years later that my life's work would be photography. Of course, as is true for most of us, it took time and effort to reach that goal. In 1982, at age twenty-nine, I began photographing nature in earnest, full-time.

Fifteen years may seem like a strange number of years to include in a book. It's an odd, not even, number. Yet asymmetry has a balance of its own—the beauty of a suspended chord, a spiraling fern, a leading onwards—a sense there is more to come. And the end of 1996 was another turning point for me. I expect that my future projects will be centered on images that represent inner worlds more than interpretations of place. We'll see. Traditional color nature photography about *place* and *subject* is now widely available and understood. I think it is time for photographers and viewers to evolve to the next level of visual communication and engage each other in a new way.

Nature's palette will continue to be my palette. It is ever-changing, yet predictable, always honest and dependable. There *is* more to come.

Photographs